Land of Pure Vision

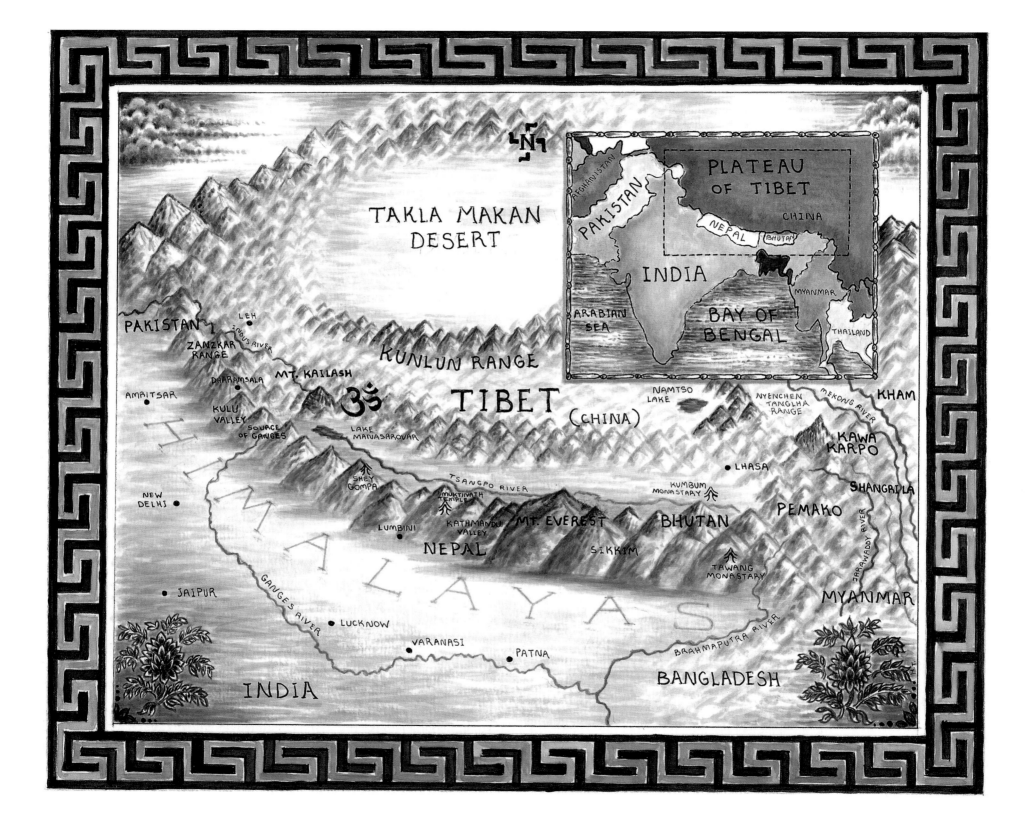

LAND OF PURE VISION

The Sacred Geography of Tibet and the Himalaya

David Zurick

Foreword by Éric Valli
Design by Richard Farkas
Map by Holly Troyer

UNIVERSITY PRESS OF KENTUCKY

Copyright © 2014 by David Zurick
Foreword copyright © 2014 by Éric Valli

The University Press of Kentucky

Scholarly publisher for the Commonwealth,
serving Bellarmine University, Berea College, Centre College of Kentucky,
Eastern Kentucky University, The Filson Historical Society, Georgetown
College, Kentucky Historical Society, Kentucky State University, Morehead
State University, Murray State University,
Northern Kentucky University, Transylvania University, University of
Kentucky, University of Louisville, and Western Kentucky University.
All rights reserved.

Editorial and Sales Offices: The University Press of Kentucky
663 South Limestone Street, Lexington, Kentucky 40508-4008
www.kentuckypress.com

Cataloging-in-Publication data is available from the Library of Congress.

ISBN 978-0-8131-4551-8 (hardcover : alk. paper)
ISBN 978-0-8131-4559-4 (pdf)
ISBN 978-0-8131-4558-7 (epub)

This book is printed on acid-free paper meeting
the requirements of the American National Standard
for Permanence in Paper for Printed Library Materials.

Printed and bound in South Korea by PACOM KOREA Inc.

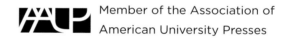 Member of the Association of
American University Presses

For Sam Mitchell (1956–2011)
In memoriam

CONTENTS

FOREWORD

It's often my search for hidden lands—*beyul*, as the Tibetans call them—that triggers my most beautiful and wild adventures. That's why David Zurick's quest in the Himalaya for what he calls sacred architectures interested me straightaway. Imagine a several years' journey crisscrossing by all imaginable means the most mysterious places in the world. Indeed, as I am writing these lines, he is preparing to go back for the last picture, carrying his large-format camera, in order to capture somehow the magic that connects human beings to these mythical places.

Although we have different backgrounds and approaches—David's those of a scholar, mine those of a cabinetmaker/Boy Scout—we are both interested in the relationship between nature and humankind: How does nature mold humankind, its culture, its tradition and . . . how does humankind mold nature in order to survive? This is the most magical alchemy. Trying to understand it takes you to the heart of life itself. How many times, reaching one of these power places—me, the atheist—did I silently pray to the spirits I could feel around me?

There is a Zen quality to this book I really like. The quality of David's photographs has to do with his artistic eye, for sure, but it is an eye nourished by an intimate knowledge of the place. This book is born from the fascination of the author with this part of the world. Above all, it is a love story. Thanks to the choice of a large-format camera, each picture pulls you in. You hear the silence, feel the wind, the cold, the peace, and the magic . . . then you begin to understand why such places have drawn so many fine dreamers and adventurers for centuries. How can one resist such magic?

No wonder I fell under the same spell when I first set foot there in the early seventies. I remember meeting a salt trader traveling with his yak caravan across Dolpo. He couldn't figure me out. He asked me: "I keep meeting you here and there for months now. Why do you come here, to such a remote and inhospitable place, if it's not for making money?"

I answered that I was not a businessman. "I just come here because I like the place, I like its people, I like to roam, and . . ."

He suddenly understood. "Ha! You're a pilgrim!"

Yes, that was the best explanation. It's now David's turn to take us along on his wide and long pilgrimage.

Éric Valli

INTRODUCTION

Landscape as Sacred Map

In 2004 I began traveling in the Himalaya and Tibet with a large-format camera and sheet film to make black-and-white photographs of sacred places in the region: monasteries, shrines, and temples; scriptural carvings on rocks; prayer flags; the sources or confluences of holy rivers; revered mountains; forest sanctuaries and hidden treasure valleys; and numerous other consecrated elements in the landscape. These spiritual features populate the rugged terrain and are among its most remarkable cultural imprints. I was interested in how they might illuminate a particular way of *seeing* the world. It is customary for scientists and others to understand natural landscapes emerging from events that take place over geological or evolutionary time, giving an ecological shape to a place, but cultural landscapes result from human intentions and design and thus convey formal elements of anthropological study: social artifacts of history, power, beliefs, or aesthetics expressed in the landscape. My photographs in this project center specifically upon places of a religious or spiritual character, and thus foremost engage with human *ideas*—about sanctified nature; a sense of place; networks of worship, religious transmission, and learning; sacred architectures; and, inevitably, about changes that overcome places with the passage of time. Photographing a religious site in this vein is not simply a matter of taking a picture of holy scenery—rather, it is akin to delving into a rich repository of landscape meaning.

During the course of the project, I came to understand sacred geography as a kind of mythic cartography, wherein the abstract coordinates of latitude and longitude one commonly finds on a map are replaced with markers on the Earth's surface that delineate a cosmological organization of the world. Geographers refer to ideal or imaginary cartograms as mental maps—images of the world we hold in our minds. They take form as we navigate life and are influenced by our personal experiences and cultural backgrounds. They help us make sense of the world. The Sanskrit concept of *mandala,* which permeates the religious traditions of Tibet and the Himalaya, is one such kind of mental map. It imagines a celestial realm on Earth that may be physically imprinted as a temple wall mural, a sculpture or architecture, a sand painting, or, in the case of sacred geography, a terrain filled with known and revered spiritual places. This transposition of religious thought to the landscape extends the planet's surface to the empyrean. It engages the natural elements, a sense of place, and networks of movement and circulation that assemble the sacred sites into a comprehensive worldview. In such ways, and for some people, the world is made holy and the landscape becomes a touchstone for a reverent calculation of life on Earth.

The Buddhist, Hindu, pre-Buddhist Bon, and Shamanic traditions of Tibet and the Himalaya all pay special homage to places that are deemed spiritually powerful by virtue of their unique geographical qualities. Such places often have physical lineaments: a summit where the sky meets the land in a kind of *axis mundi* connecting heaven and Earth; the confluence of two or more rivers; a cave; a hot springs where fire meets water; or the upwelling source of a river. Spiritual practice transforms such geomorphological settings

Opposite: Shivling Peak, India, 2004.

into auspicious sites. Other sacred places have direct human origins: the birthplace of a saint, the architectures of monasteries and temples, hermitages and meditation shrines, or the residence of miracles. Here, too, their consecration as sacred places requires acts of devotion and ritual. Pilgrims journey among the sacred places of Tibet and the Himalaya in ages-old quests of atonement or to gain spiritual merit, following the mental trajectories of their divine mandala space much as a cartographer might delineate the pixelated lines on an electronic map.

In these ways, geography and faith combine to provide one with an enduring sense of place in the topography of Tibet and the Himalaya. Abode of deities, the mountains also are home to humankind. In making geography sacred, people strive to create meaningful and safe places to live amid the powerful forces of nature by etching the landscape with the inscriptions of human consciousness. When I first went about making photographs in landscapes containing such elements, I imagined them to be a kind of portal into the systems of belief from which they sprang—not literal thresholds into a supernatural realm, as might be imagined in some arcane religious practices, or even as simple religious scenery, but rather as revelatory of how a people or society might understand life and the natural world. I later came to realize, in my selection of places to photograph—their angles of repose, quality of light, evocations, and so forth—that I also was engaged with my own personal appraisal of sacred places in Tibet and the Himalaya. I, too, was embarked on a kind of spiritual journey—a picture pilgrimage.

Change, of course, is inevitable—in the landscape, among human societies, and within a person's life. It is a foundation of religious thought in the region, the very nexus of existence, and applies equally and in full measure to the spiritual elements of a landscape. While it might arise from the mental coordinates of faith or ritual practice, sacred geography in Tibet and the Himalaya is anchored to tangible places and abides the transformations in the landscape that occur alongside the broader shifts in society. It is testimony to the resiliency of faith in the region that so many sacred places remain significant to so many kinds of persons. Despite their visible alterations or the social and environmental dislocations that may arise among their cultural settings, the sacred landscapes remind us that we live together in a world of mystery and beauty, where the human spirit is in synchronicity with natural forces.

An Expeditionary Note on the Photography

Working with a big camera, I sometimes felt the urge to drop it from a cliff and free myself of its weight and cumbrousness. That feeling would arise most commonly during a long uphill climb when I was exhausted, or when I had to tediously load sheets of film into holders while the wind was blowing a gale and my fingers were numb from the cold. Mostly, though, I was happy to carry it into the mountains. The business of setting up a big camera always forced me to slow down and work carefully, which perfectly matched the purpose of my project. And when finally I centered myself into an image, peering with stillness through the camera lens at the

unfolding world, I couldn't imagine a better place to be at that moment. I was provided with countless unique opportunities to see the region close up and below the surface, and also to finally imagine it on a grand scale as having a kind of ritual as well as geographical cohesion.

During the course of the project, I had occasion to visit remote spots, some of which required long and arduous treks. The logistics of this were always difficult and the physical challenges sometimes daunting. Elsewhere, my photographs centered on easily accessible spots, including towns and tourism destinations. At first I thought it was necessary to concentrate my efforts on the difficult-to-reach spots, thinking they would be less disturbed and, therefore, somehow more truthful and authentic. I was mistaken, of course, because accessibility has little to do with a spiritual comprehension of the world or, for that matter, the authenticity of a place. Many of the sacred landscapes in Tibet and the Himalaya are accessible and open to view. To visit them requires no more specialized skills than a simple determination to go there. Places are changing fast, though, and as a result, some of the holy places are disappearing from view—in the extreme case we are left with the ruins in Tibet, but more commonly they become difficult to see simply because their surroundings are increasingly cluttered with the trappings of a secular society.

Naturally, I suppose, at the beginning of this project I first sought to focus my camera in such as a way as to achieve a "clean" and desirable image of a place or subject by excising the evidence of modernity. This is a relatively easy thing to do. In pictorial isolation, the sacred places of Tibet and the Himalaya would appear as pristine and unadulterated landscapes. I came to understand, though, that such a highly edited portrait, however romantic, was not at all what I had in mind. I was interested in visual confliction as much as equanimity in the landscape. I learned that the theme of the project would not be an elegy but rather a portrayal of how religious practice in the modern Himalaya sustains sacred places—remote or near, new and old—and how these places may undergo transformation as the societies from which they sprang continue to evolve and change. To see a consecrated place that is radically altered is not to say that it has disappeared from sight; finding a spiritual meaning in the landscape is always a point of view.

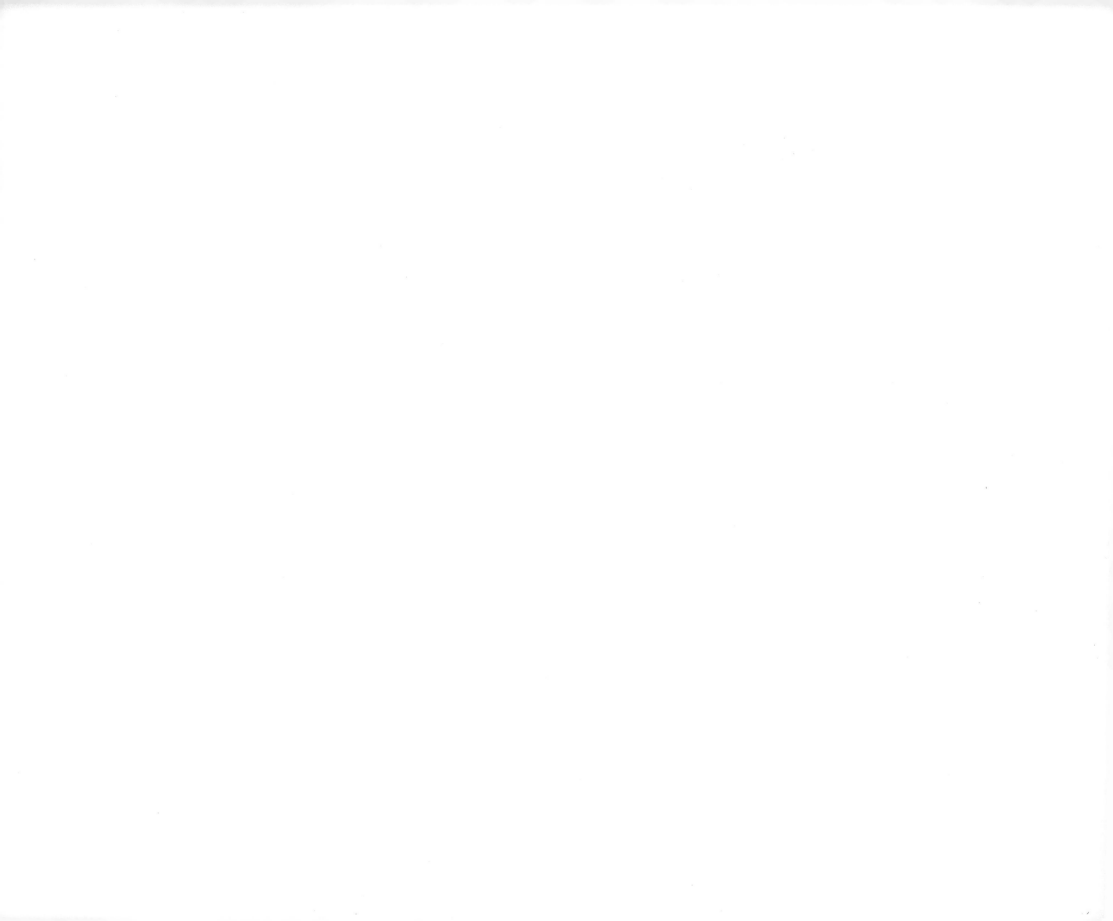

Land of Pure Vision

NATURE

Geographers refer to mountains as high-energy environments due to the restless powers of tectonic uplift, gravity, and erosion. Working together in a geological cycle, these forces give rise in Tibet and the Himalaya to some of the planet's grandest architectures—a vast tableau of crystalline peaks, valleys, and sedimentary plateaus. The soaring topography blocks moist air circulating from the tropical ocean to produce seasonally intense precipitation along the southern flanks of the Himalaya, causing landslides and floods that threaten human life but also producing fertile farms at the low elevations and vast glaciers in the highlands. The varied terrain and hydrology of Tibet and the Himalaya, in turn, produce a kaleidoscope of natural habitat—with each adjustment in the repose of the land is yet another distinctive ecological setting that supports an astonishing array of native plant and animal life.

More than 50 million persons live within the seismic folds of the Himalaya. Their religions equate natural elements in the landscape with the emanation of deities and endow certain places with spiritual qualities. It is as if such designations recognize the inherent energetics of the natural world and channel it for religious effect. This could be understood in the case of a sacred summit such as Shivling in India, whose verticality might seem to connect Earth and heaven; of a holy river source—the headwaters of the Ganges, for instance, where water spouts directly from the snout of a receding glacier; of a spring bursting forth from the land itself; of a cave penetrating deep into the Earth's crust, such as those found in the Yerpa Valley of Tibet; or of a grove of ancient trees whose ecological processes conduct the flow of energy through a connective web of plant and animal life. Religious practice imposes order onto the natural features to fit broader supernatural reckonings of the world. A holy lake, for instance, might be filled with demons that must be placated, or a mountain peak might be the residence of a god worthy of worship. Some hidden lands, called *beyul*, are believed to contain hidden spiritual treasures left behind by a great saint. These places are the holy of holies. The upper Yolmo Valley in Nepal enjoys such a designation. In myriad ways, the physical landscape expresses an animated cosmology. To sanctify nature, though, is also to placate wilderness, to make it known and accessible, and to demarcate boundaries that distinguish sacred from profane space. Ironically, the very idea of sacred geography is both transcendent and reductive: it provokes inquiry into the place of a person in the world and transforms a natural place into a sanctified realm, but it also harnesses the wild and inexplicable aspects of nature to cultural matters of faith and ritual practice.

Opposite: Ganges headwaters, Bhagirathi River Valley, India, 2004.

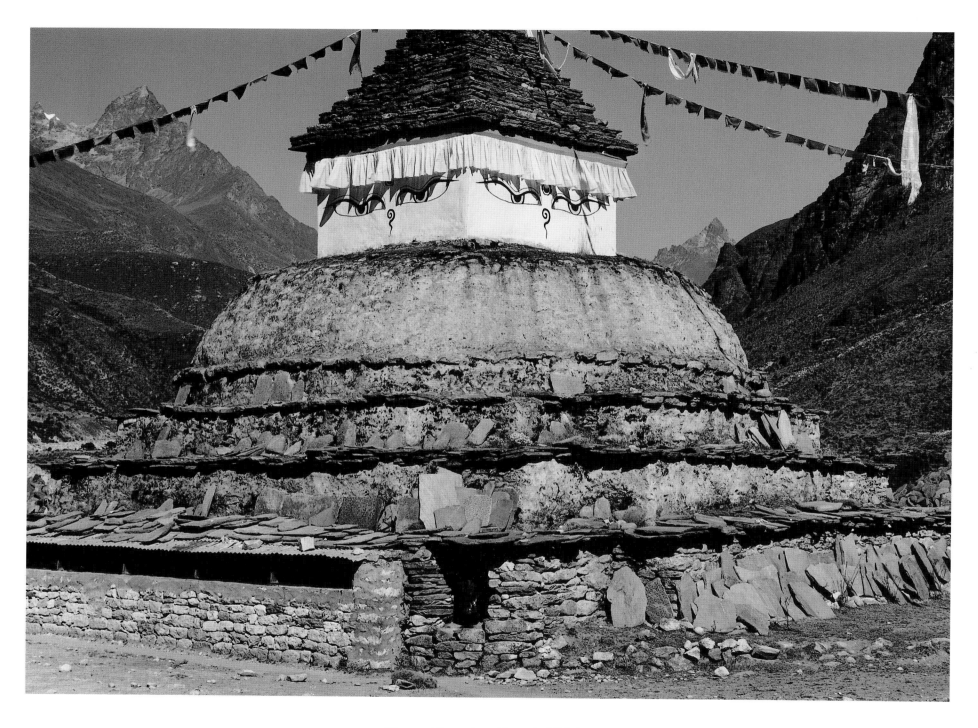

Stupa, Khumbu, Nepal, 2004.

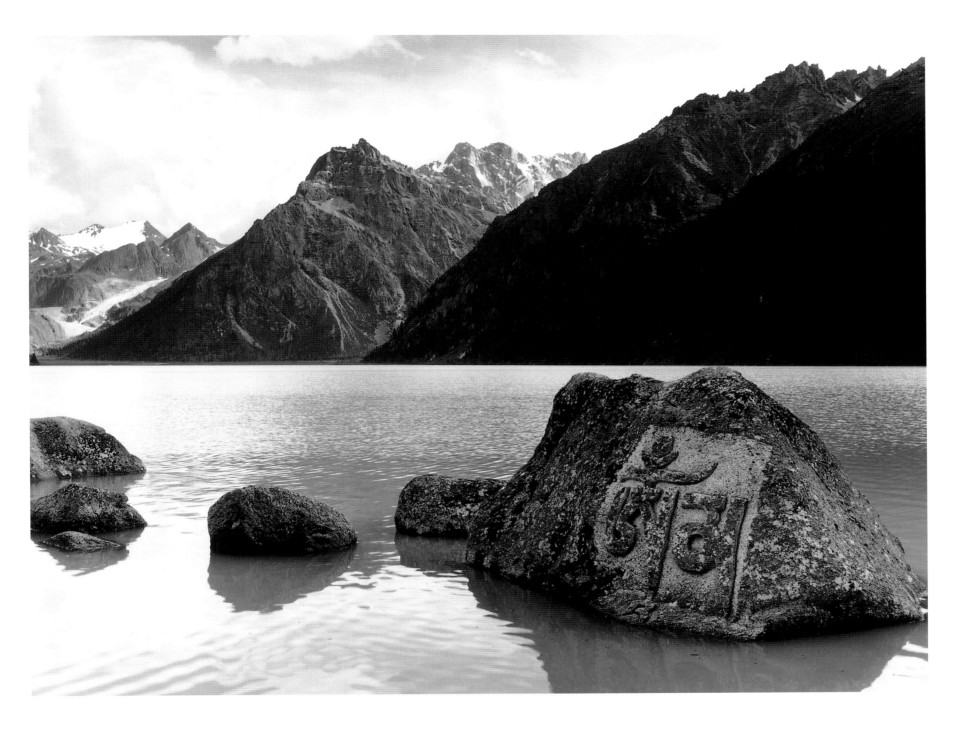

Yilhun Lhatso, Tibet (Sichuan, China), 2006.

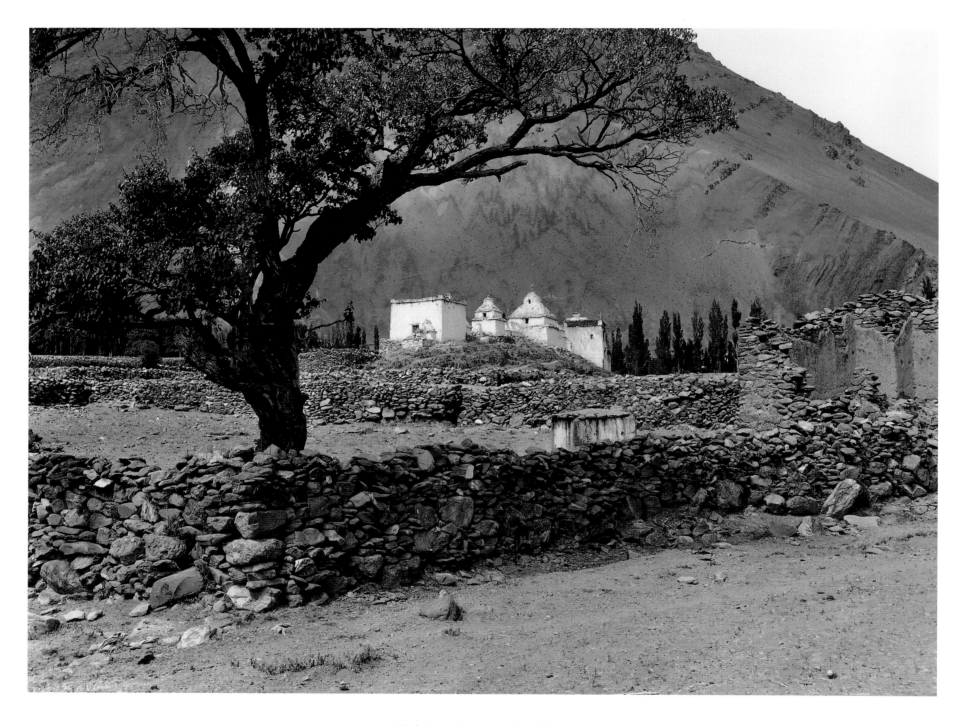

Alchi, Ladakh, India, 2004.

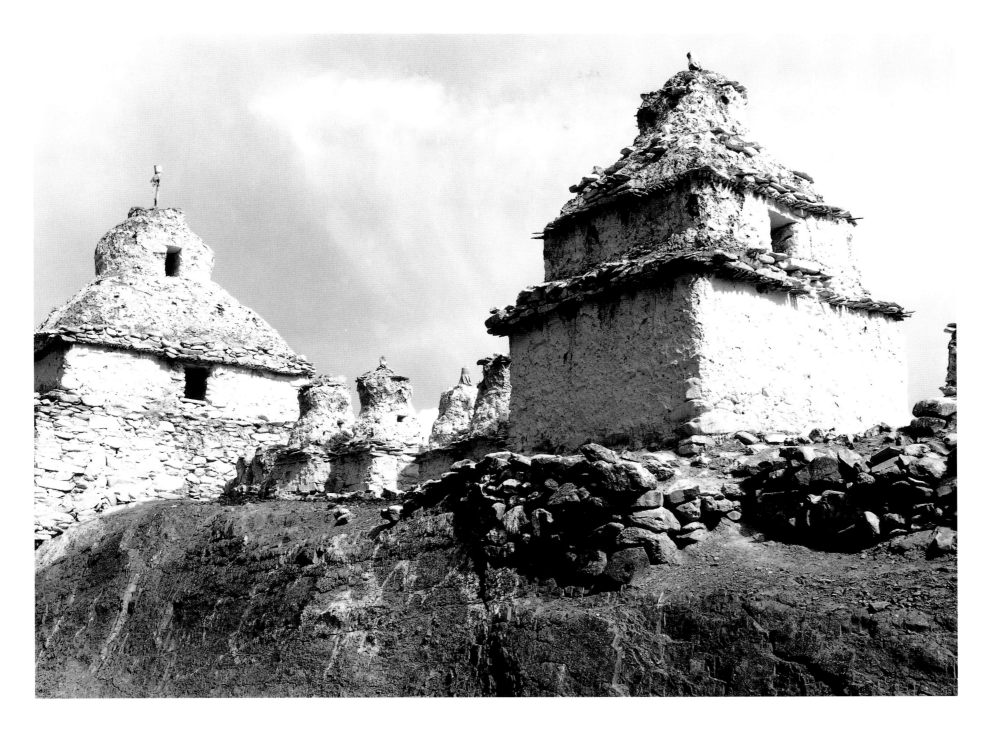

Alchi, Ladakh, India, 2004.

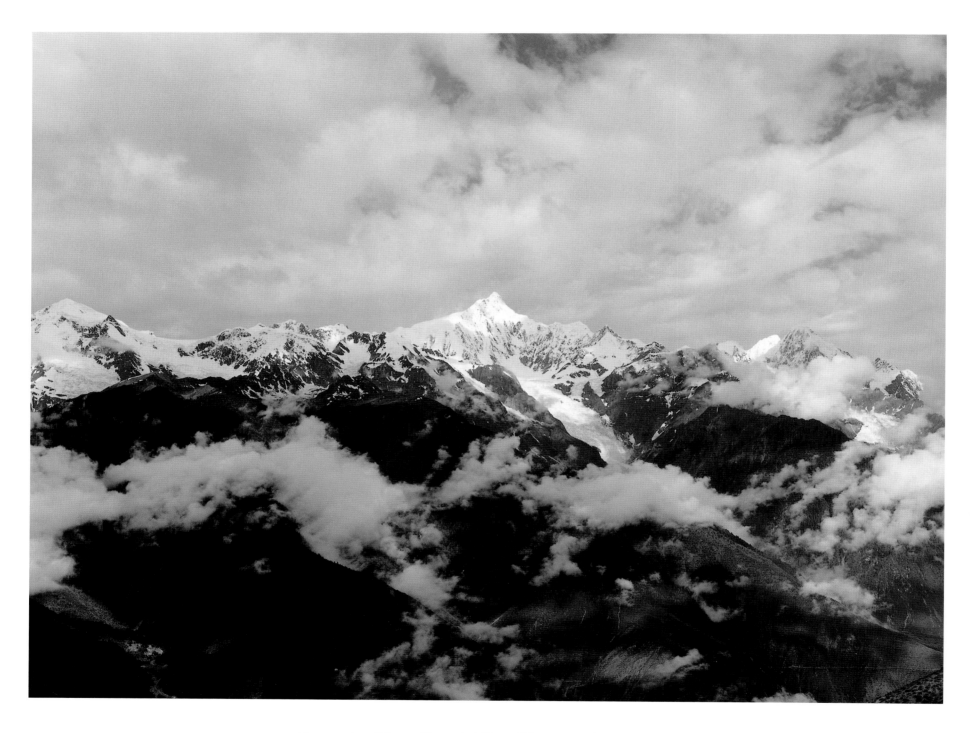

Kawagebo (Kawa Karpa), Tibet (Yunnan, China), 2006.

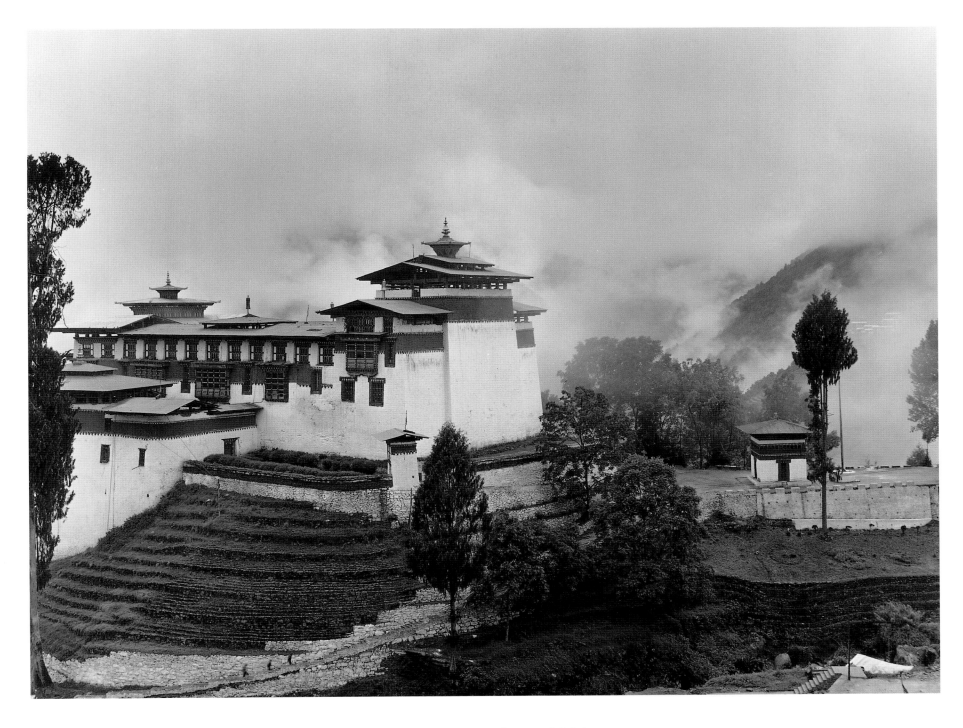

Trongsa Dzong, Bhutan, 2004.

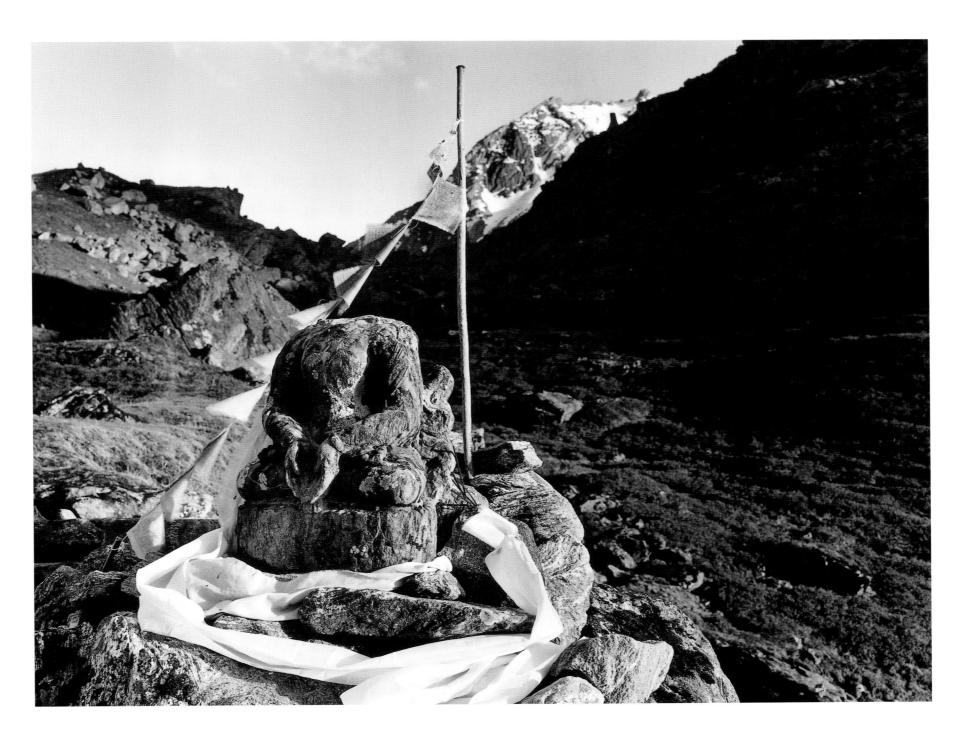

Headless Buddha statue, Nepal, 2008.

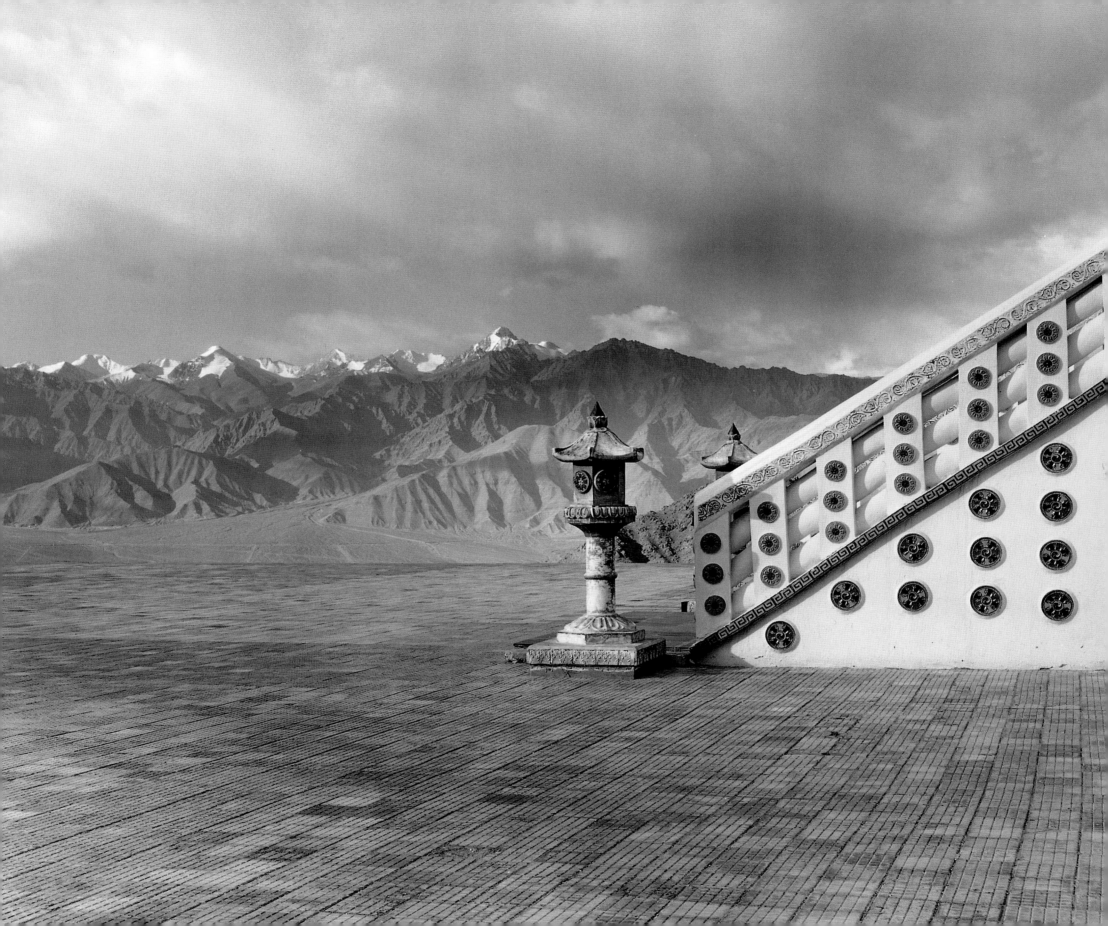

PLACE

The geographer Yi Fu Tuan employed the term *topophilia* to describe the affinity a person may have for a place. He suggested that such affinity comes from a sense of both love and fear: love in the way that place-based experience and emotion create a flourishing and even devotional relationship to a particular spot on Earth, and fear in the perception of real and present dangers in the world—floods, famine, earthquakes, and disease. Both emotions are present in the sacred landscapes of Tibet and the Himalaya. The all-encompassing divine love that undergirds much of religious devotion is magnetic when it is applied to certain places, drawing in devotees hoping to experience a spiritual revelation or to gain personal salvation. Simultaneously, a fear of wrathful gods compels some people to pay homage to a spirit believed to dwell in a place. The wish to visit—or to avoid—the abodes of saints or the lairs of demons is to populate the Earth with places of tangible hope and appeasable danger. In such ways, a powerful sense of place, manifest as *mysterium tremendum,* holds sway over the minds of the faithful, and certain localities are deemed more auspicious than others. Such natural places become *sacred* places.

The instructions of religious teachers may also attract devotees to a certain spot. Their invocations, whether written down in liturgy or recounted in oral history, provide spiritual sustenance for people moving through a world that seems unruly and diffuse. In this way, a sacred place may be the site of a monastery or a temple; a mountain cave or a river source where a famous saint once meditated; a hidden scripture-filled treasure valley such as those believed to exist in Bhutan; or, more abstrusely, a landscape that is filled with a vague and generalized sense of divine energy in natural transmutation. The mythologies of Tibet and the Himalaya are replete with such places, and guidebooks exist for pilgrims wishing to visit them. Sacred places become the geographically determined points on a supernatural trajectory, much as the intersecting lines of latitude and longitude establish coordinates on a map.

Cartographic topologies, however, are limiting—mathematically derived abstractions set into a two-dimensional grid representation of the world; the sacred places of Tibet and the Himalaya, on the other hand, are filled with emotion, ritual, and spiritual insight. One can determine a Cartesian relationship between points on a map and places on the ground using technological devices such as a Global Positioning System, but a sacred geography can be realized only through faith and devotion. Even then, though, most sacred sites require some kind of demarcation on the ground to be recognizable—for example, the symbolic architecture of a religious structure, a wall of stacked scriptural rock tablets along a path, a *stupa* in a forest grove or a cairn placed atop a mountain pass, or a carved statue or painted mandala set inside a temple. These sacred intaglios create places that people rely upon to navigate a mysterious world of deities and demons, hope and despair, and—always—the unfolding human consciousness.

Opposite: Shanti Stupa (Peace Pagoda), Ladakh, India, 2004.

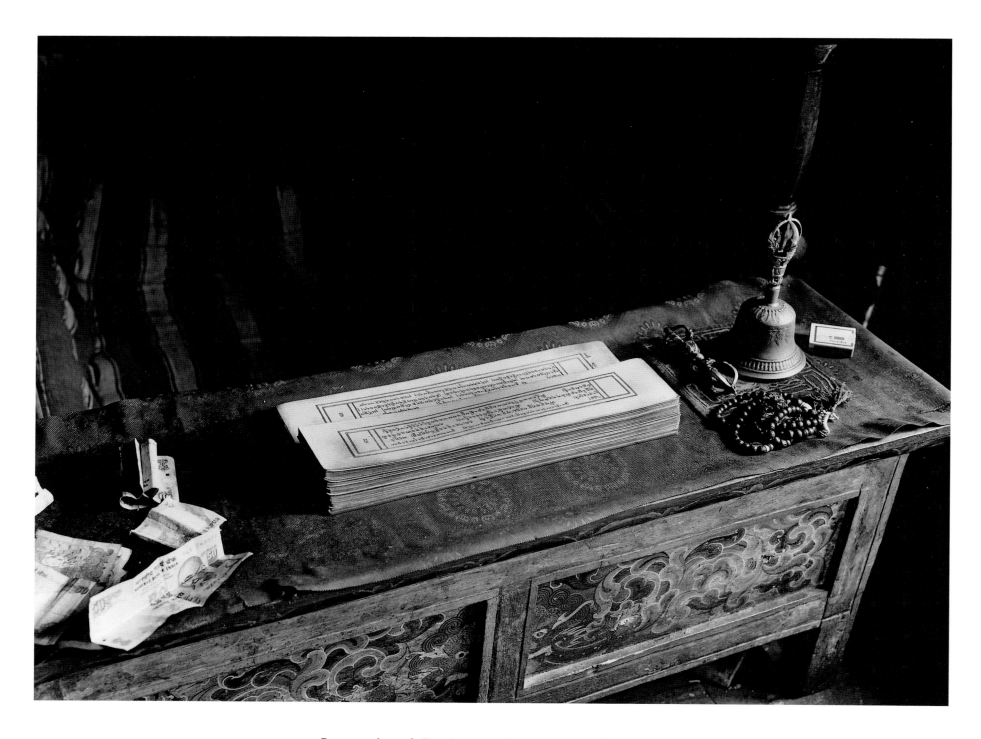

Prayer chapel, Temisgang Monastery, India, 2004.

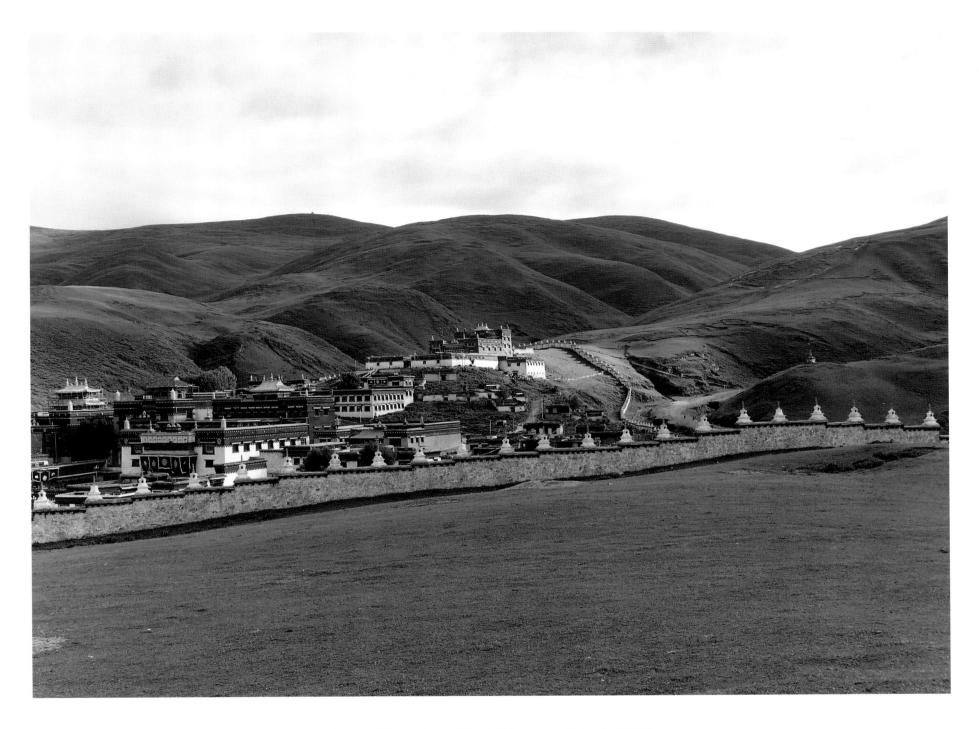

Litang Monastery, Tibet (Yunnan, China), 2006.

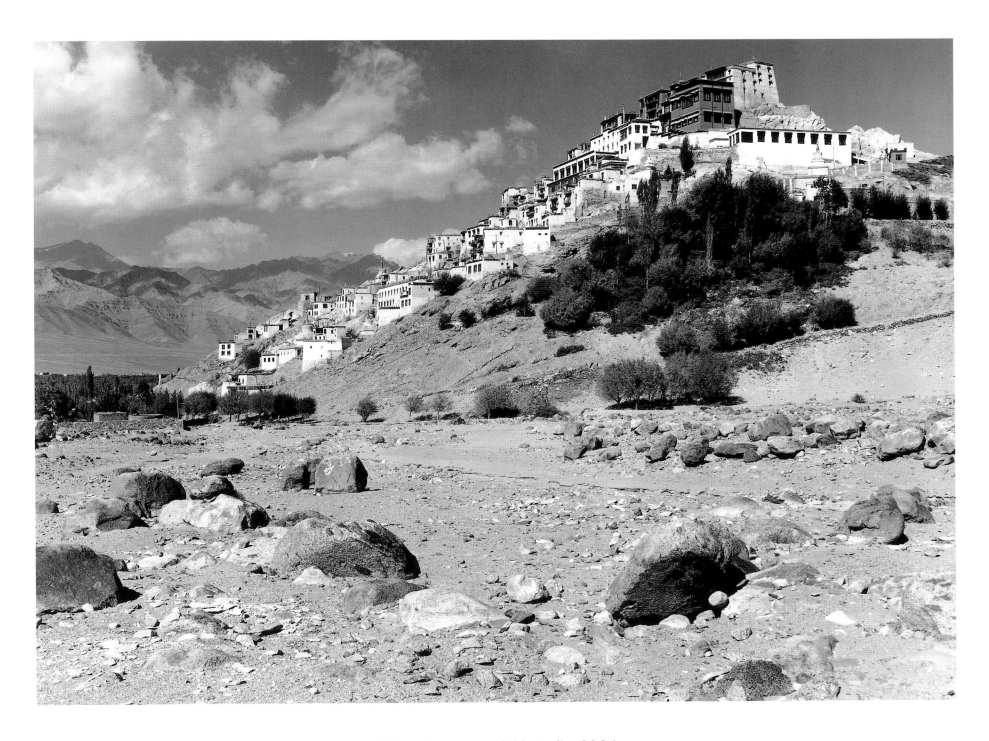

Thikse Gompa, Ladakh, India, 2004.

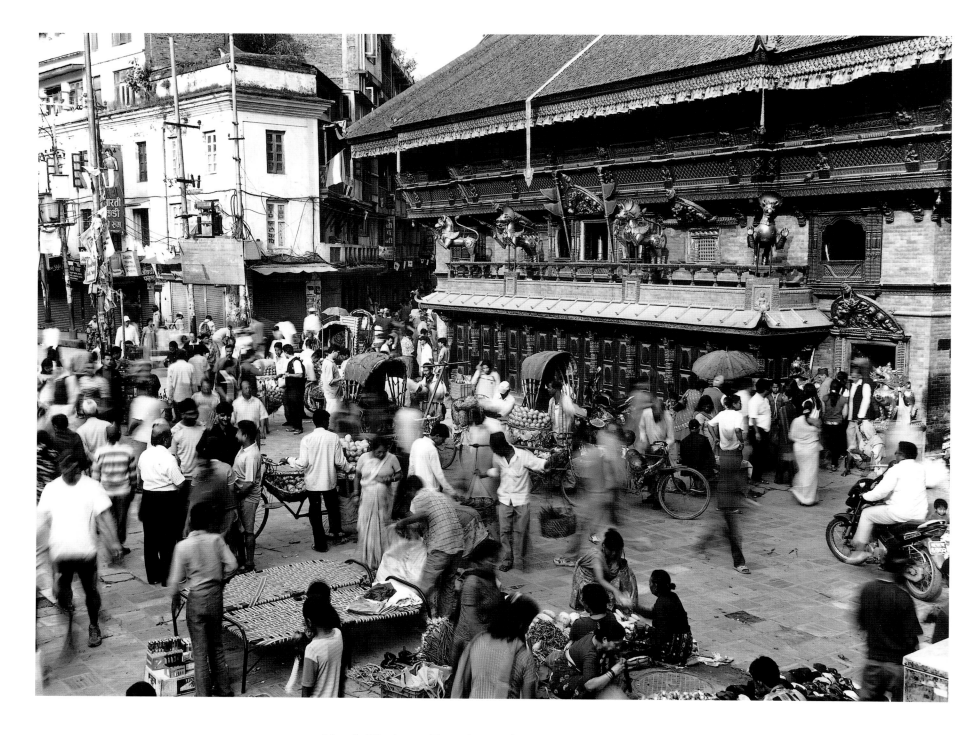

Akash Bhairava Temple, Kathmandu, Nepal, 2008.

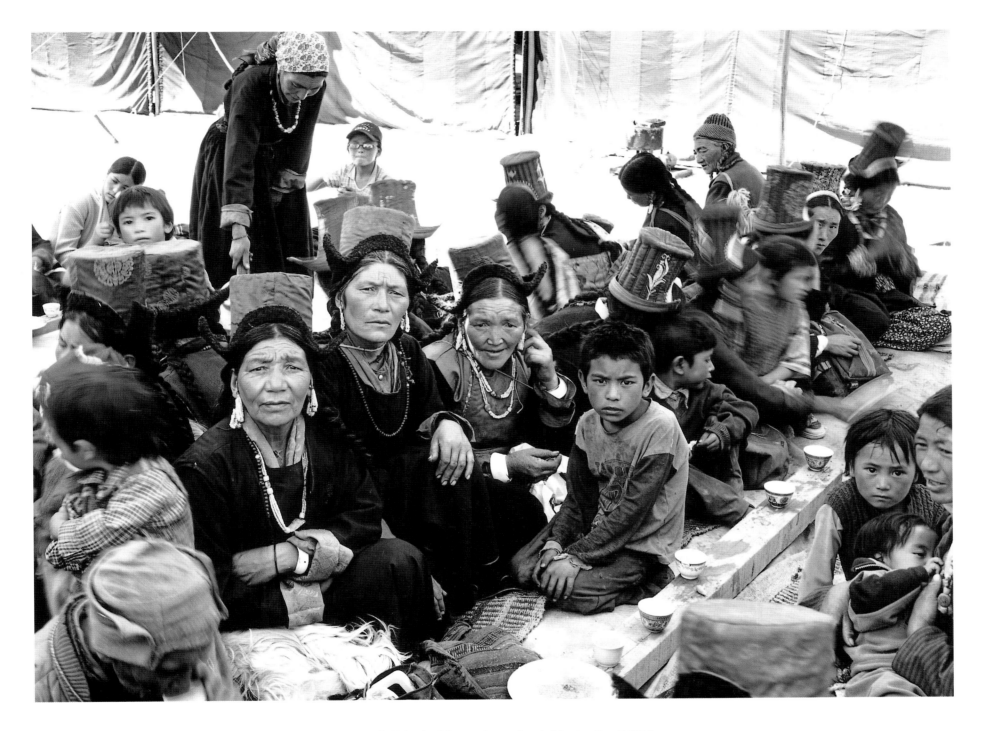

Festival, Wanla Monastery, Ladakh, India, 2004.

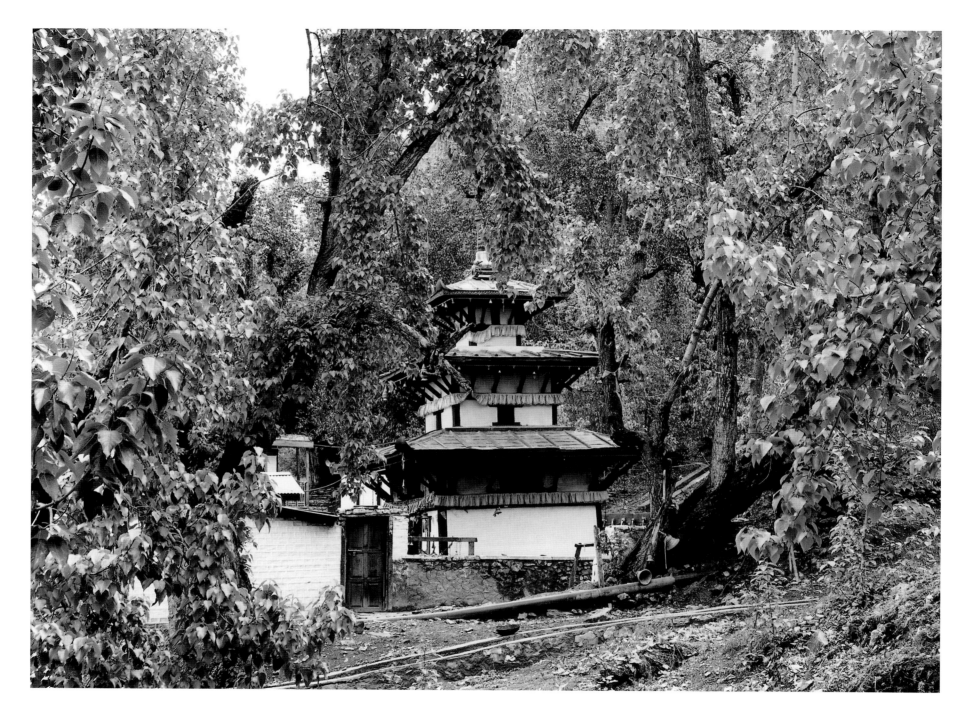

Muktinath Temple, Nepal, 2008.

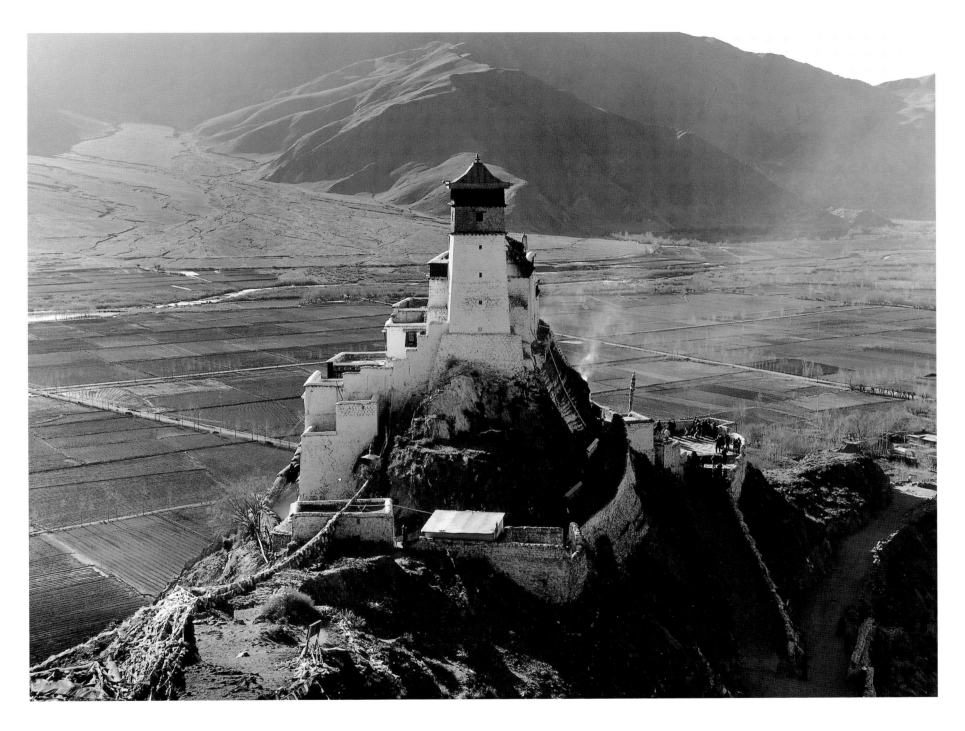

Yumbulagang, Tibet, 2009.

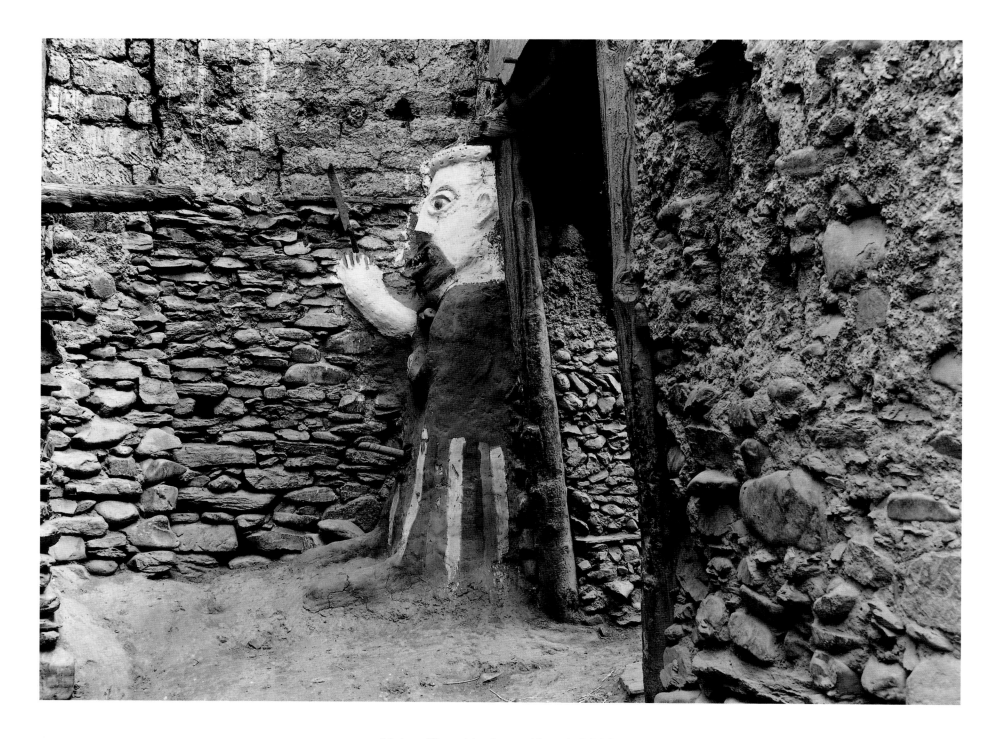

Male effigy, Mustang, Nepal, 2008.

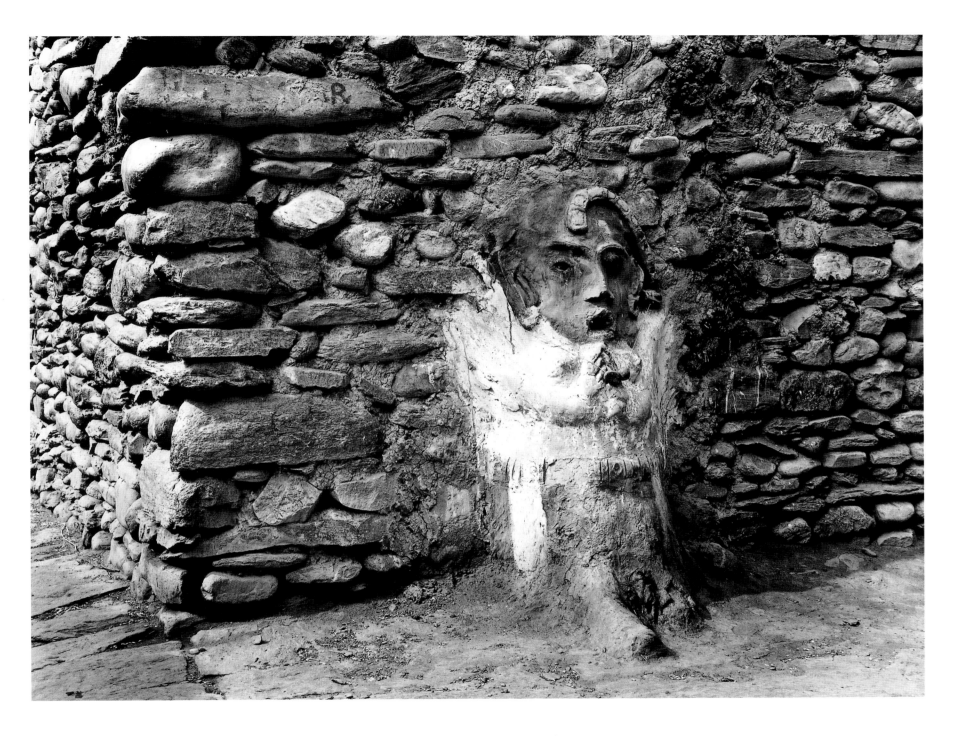

Female effigy, Mustang, Nepal, 2008.

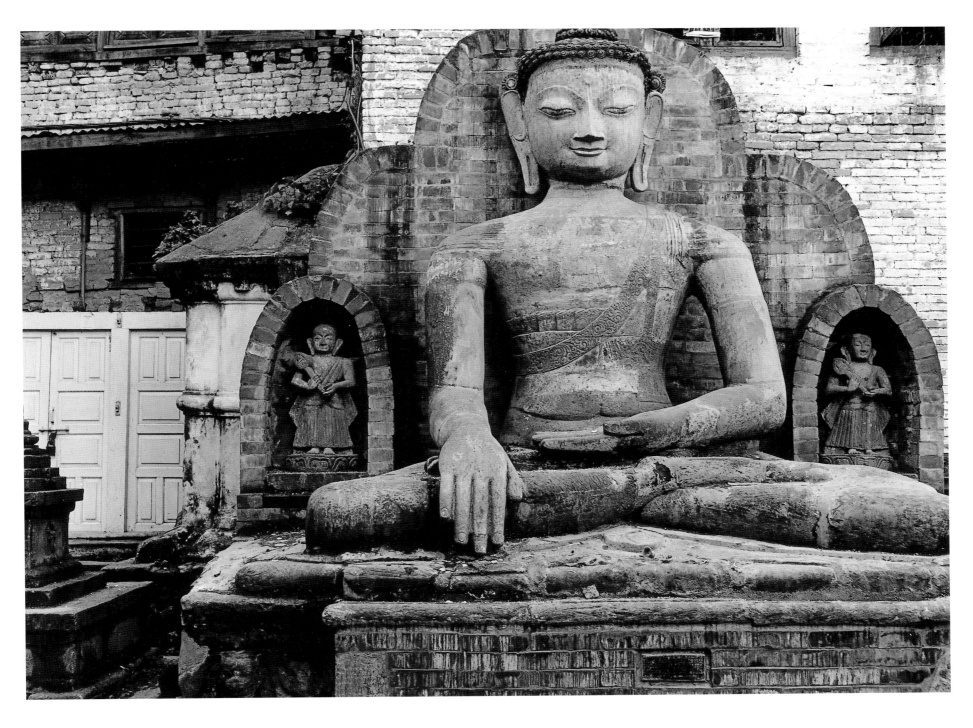

Meditating Buddha, Swayambunath Temple, Kathmandu Valley, Nepal, 2004.

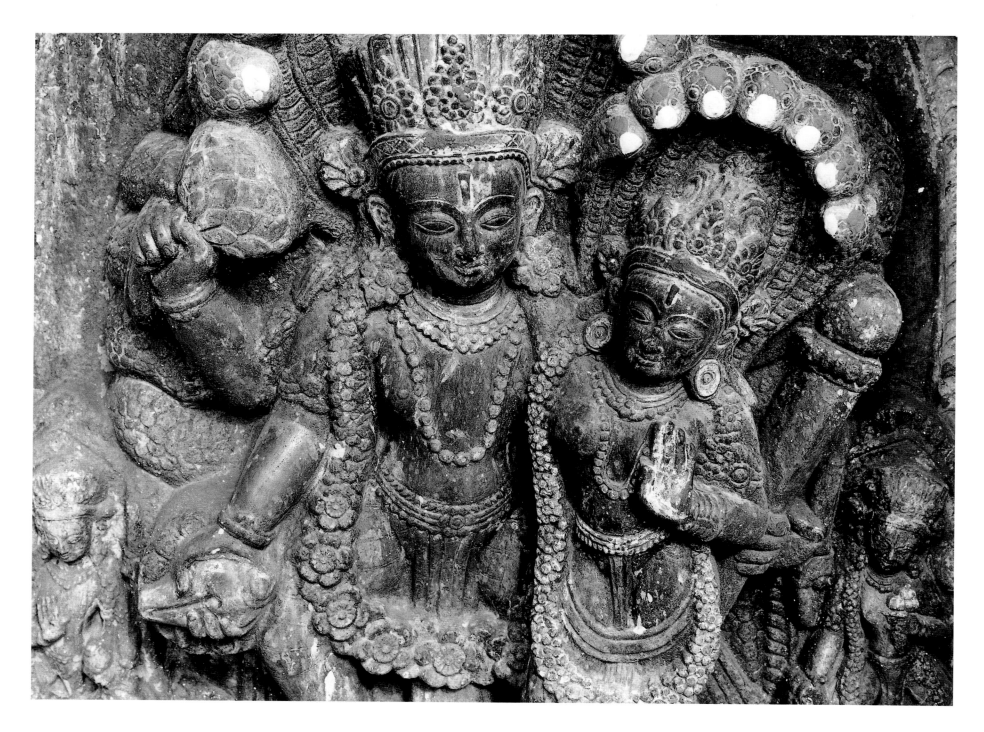

Laxmi-Narayan Pond, Kathmandu, Nepal, 2008.

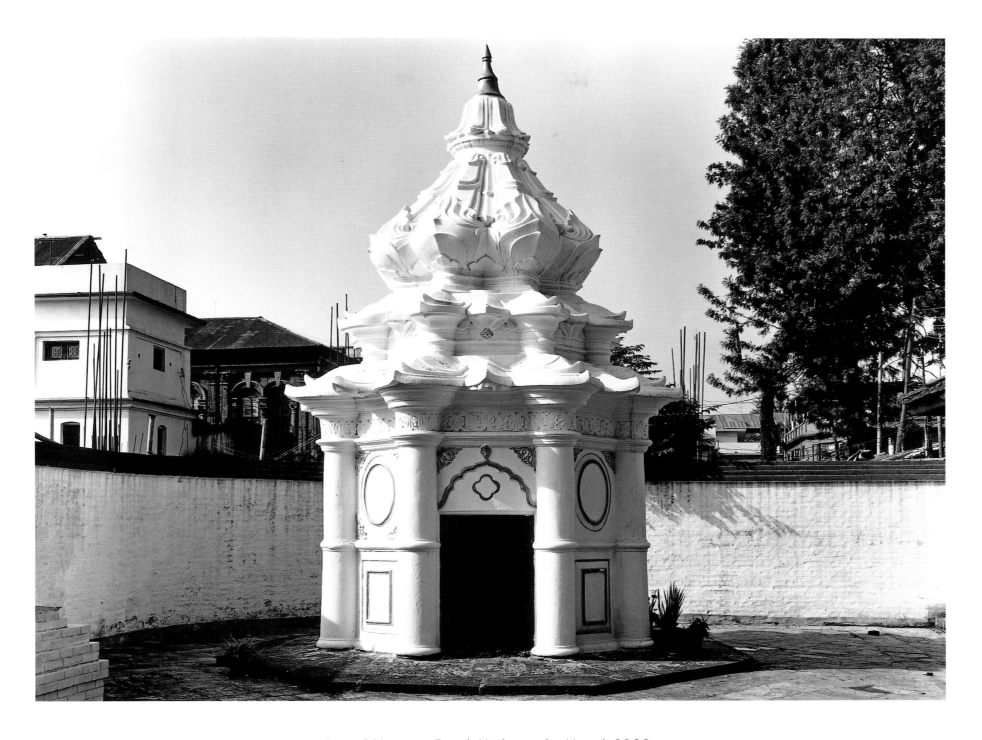

Laxmi-Narayan Pond, Kathmandu, Nepal, 2008.

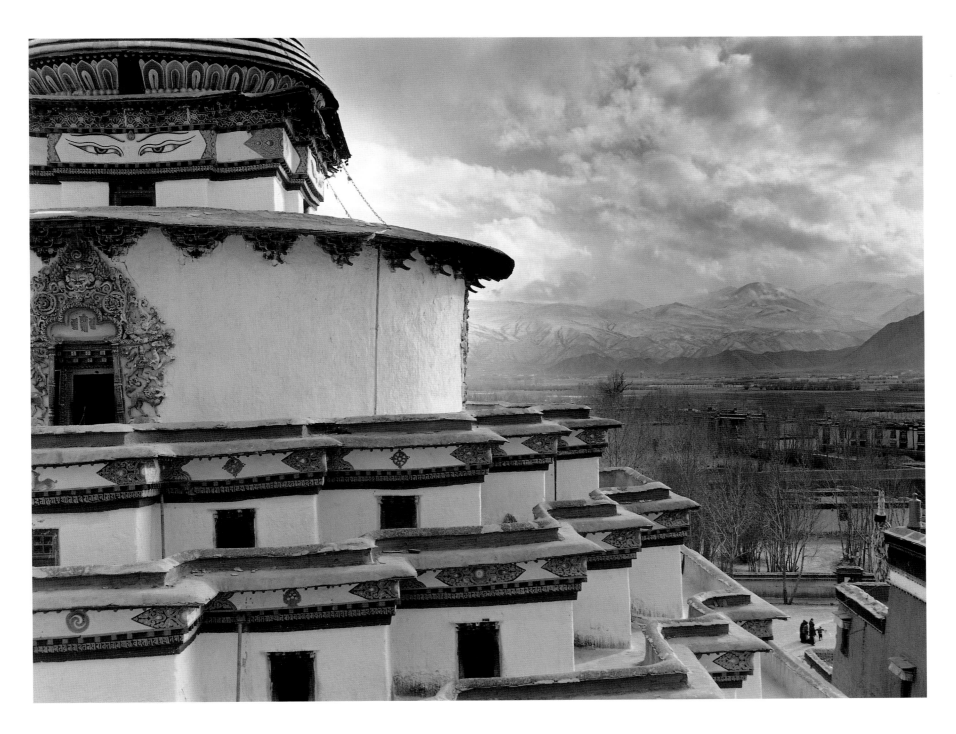

Kumbum, Gyantse, Tibet, 2010.

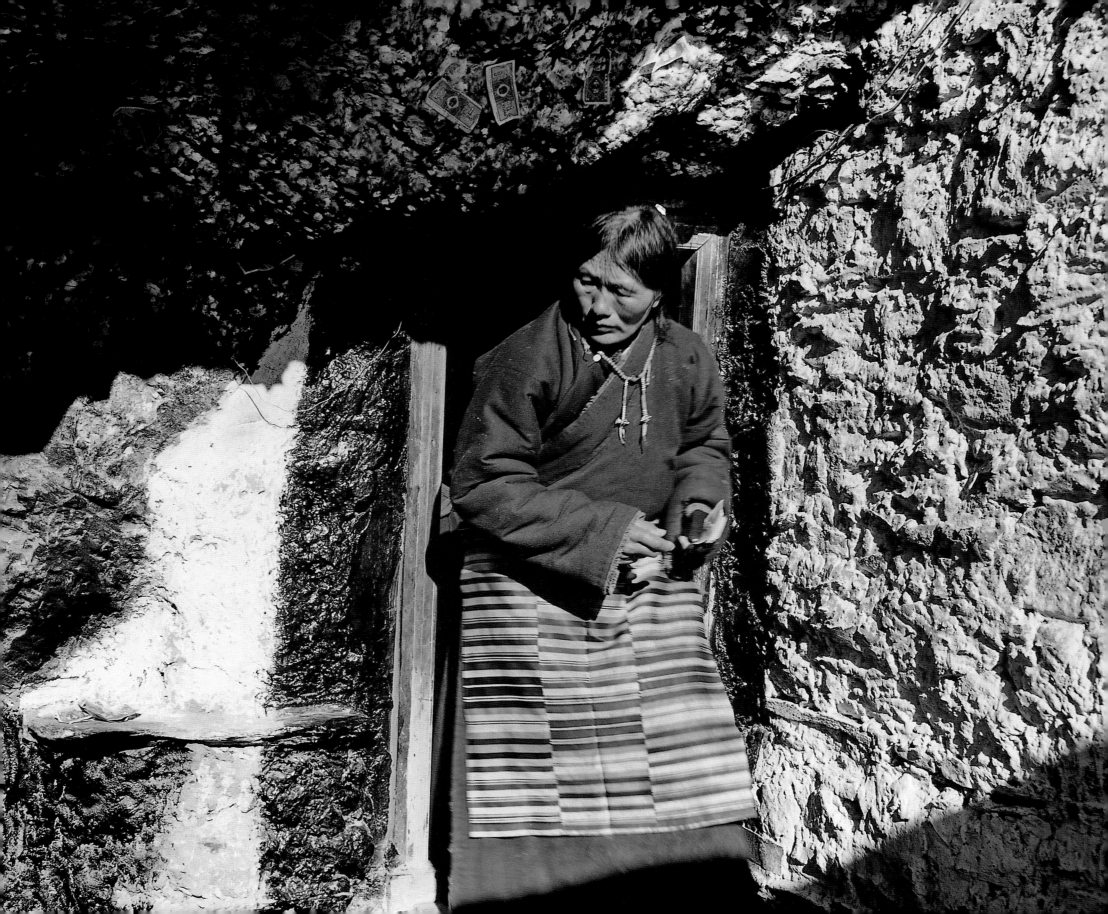

GALLERY THREE

NETWORKS

The places that appear in a sacred geography of Tibet and the Himalaya do not exist in isolation but rather are interwoven within a spatial grid of pilgrimage routes, ceremonial grounds, scriptural transmissions, and trailside markers, all made cohesive by religious practice. On a purely cosmological level, such connectivity may be perceived as a divine energy flowing across a landscape and through the heart of a person. This may be the case, for example, for Buddhists who view the plateau of Tibet as a pure land of enlightenment offering personal salvation from the endless cycles of karmic rebirth. It may apply to Hindus traveling to the four sources of the Ganges River, for whom the flow of the river is a fluid manifestation of divinity. A mythological equivalent might recount the peregrinations of a famous shaman or saint whose meditations and arcane teachings created holy spots that are ritually interlaced by pilgrimage. The transmission of sacred teachings at centers of religious study and beyond to a wider populace further circulates liturgical knowledge and sacred observation.

For people who practice an everyday kind of religion, the sacred places are most routinely connected by ritual and spiritual travel. This might entail visiting a neighborhood shrine or embarking on a once-in-a-lifetime expedition to a remote sanctuary. The distance matters not. Pilgrims follow a prescribed route, circumambulatory in nature, and are required to complete specified rituals at designated stopovers. Such spiritual travelers in Tibet and the Himalaya often endure lengthy journeys, frequently by foot and across rugged terrain—a stereotypical pilgrimage, but it also is common for them to travel in vehicles and to lodge in comfortable accommodations. In any event, the pilgrims provide a tangible—and humane—reminder of how faith and geography combine to produce networks of religious circulation.

To think about Tibet and the Himalaya in this way suggests a shared worldview among many of its residents—a kind of mental mandala cast across the region that compresses an entire cosmology onto the Earth's surface. Adepts of arcane Buddhist and Hindu scriptures are keen to discern such an ephemeral cartography and to locate within it the rootedness of genius loci. A pilgrim passing through a sanctified landscape moves among its sacred features, distinguishing metaphysical boundaries in the landscape, and consciously registers the gravitas of a sacred place. Pilgrims, in fact, by their very act of movement, *become* a connective tissue in the spiritual networks that compose a sacred geography. A pilgrimage thus is simultaneously a topology of the human spirit, an invocation, a journey of purification and merit, and the affirmation of a sacred ecology that binds faith to nature and both to a spatial ontology that resides deep within a religious reckoning of the natural world.

Opposite: Pilgrim, Drak Yerpa, Tibet, 2010.

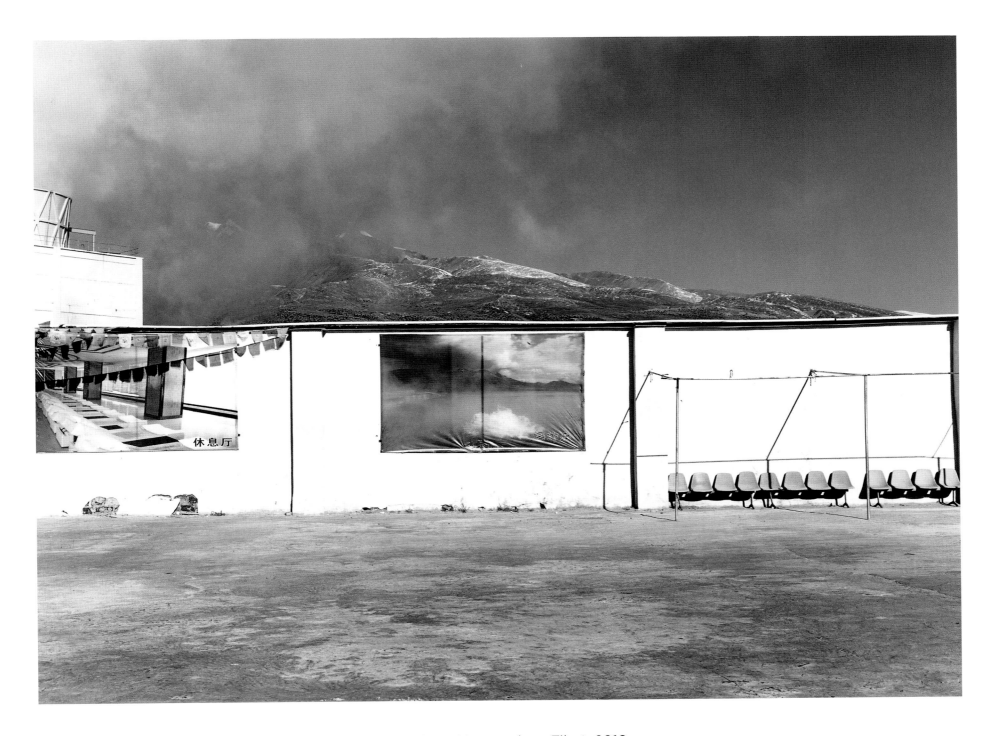

Hot springs, Yangpachen, Tibet, 2010.

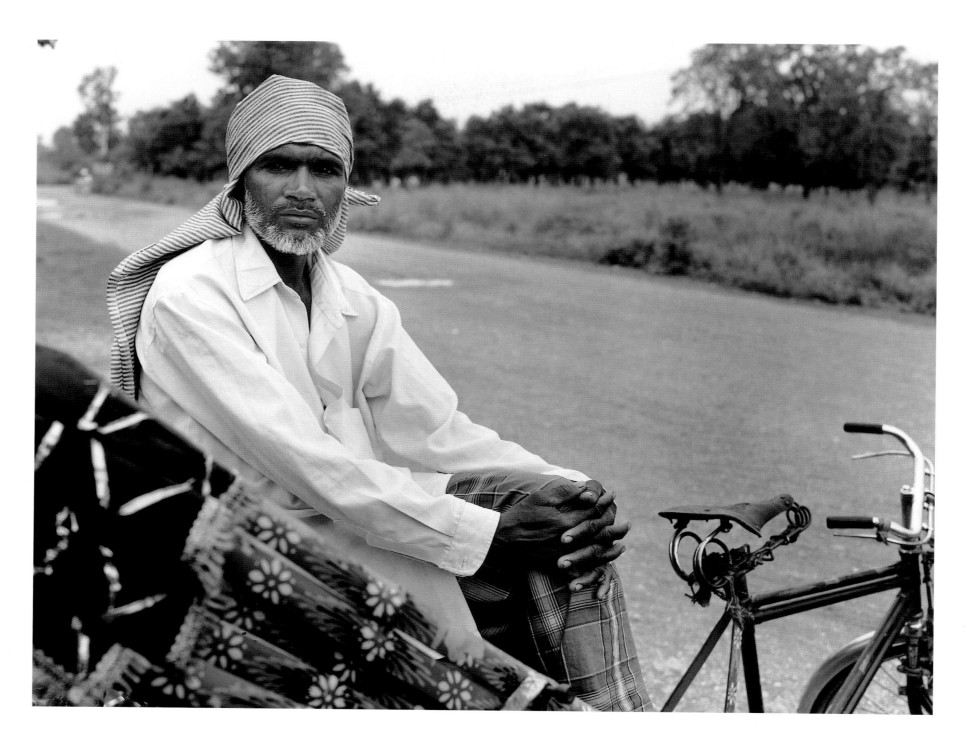

Rickshaw puller, Lumbini, Nepal, 2008.

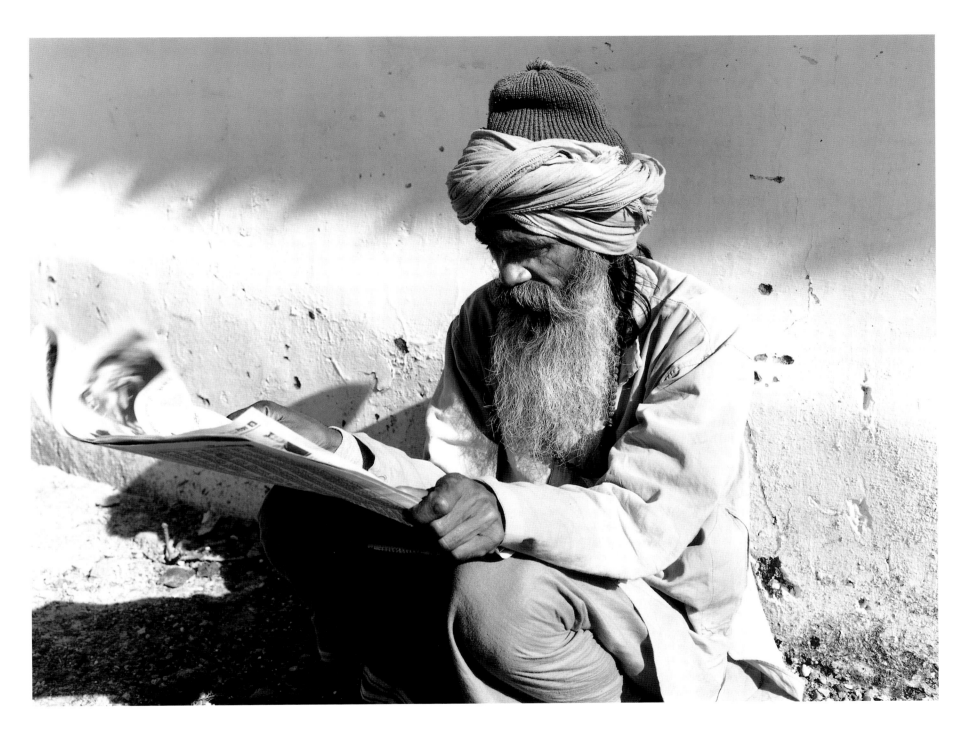

Ashram resident, Rishikesh, India, 2004.

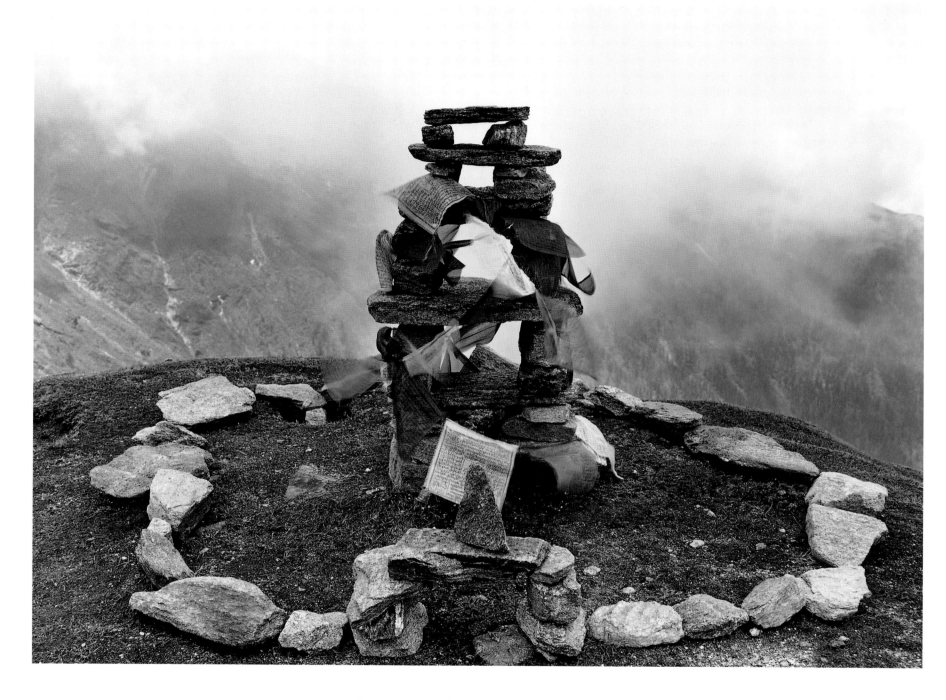

Cairn, Laurebina Pass, Nepal, 2008.

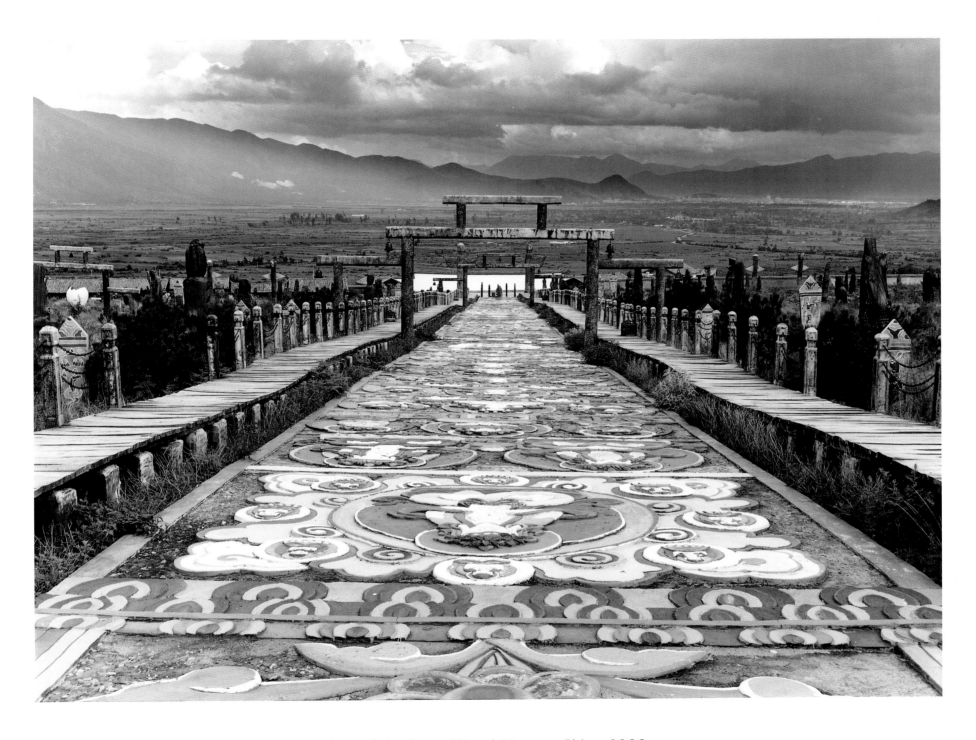

Map of the Sacred Road, Yunnan, China, 2006.

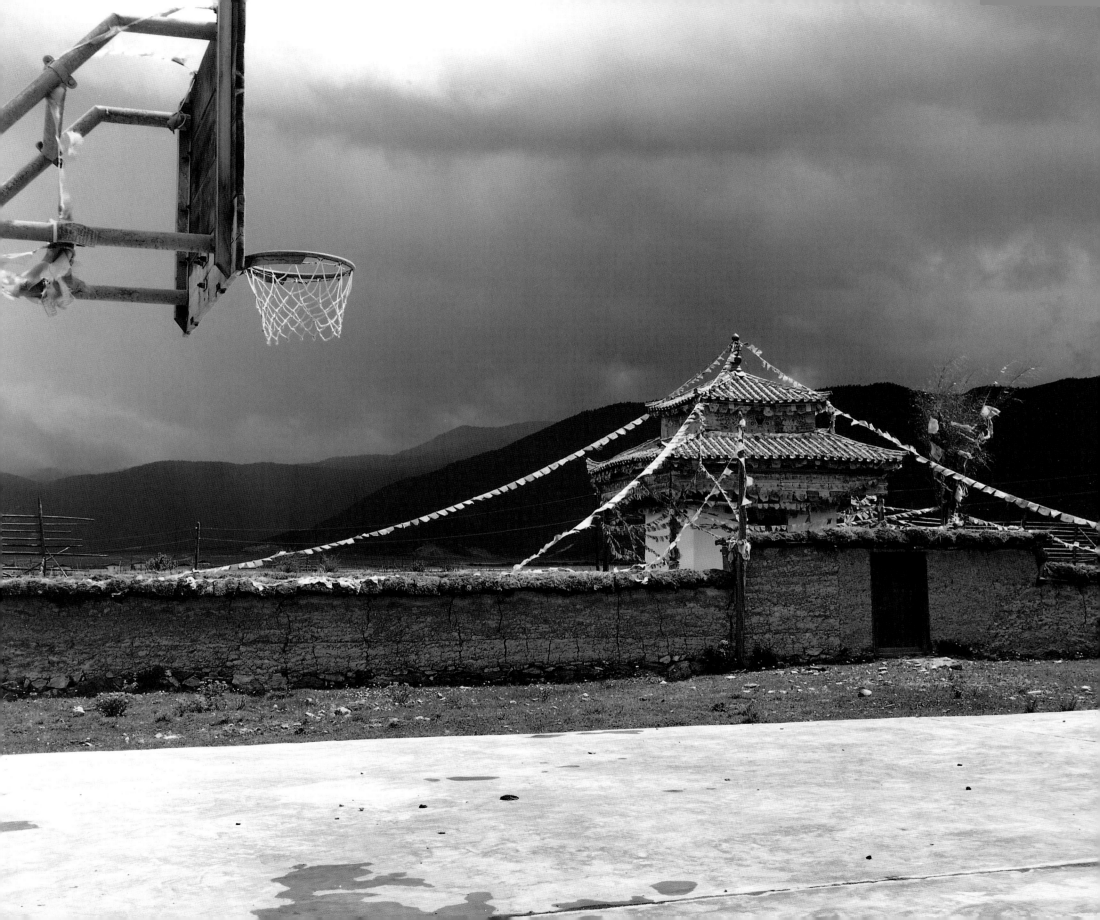

GALLERY FOUR

CHANGE

Change and dissolution are among the hallmarks of religious thought in Tibet and the Himalaya. From its inception, Tibetan Buddhism has stressed impermanence as essential to spiritual liberation—all attempts to cling to the past will result only in future suffering. The Hindu concept of *samsara* explains all existence as a continual cycle of birth, life, death, and rebirth. Karmic theory embraces the transmigration of a person's soul. Even death will not stop change. The Shamanic traditions of the region are founded upon the ideas of altered states of consciousness and the interlocution of reality and the supernatural. It stands to reason, then, that transformation and dissolution should describe the sacred elements of landscapes that feature so prominently in the practice of these faiths. Temples fall apart; glaciers recede and sacred springs go dry; bombed monasteries are renovated along lines of questionable provenance; deity statues slowly succumb to rot, pilferage, or erosion; spiritual technologies undergo innovation; and pilgrims move along newly tarmaced surfaces. Sacred geography in its visible manifestation is a transient concept, and its superimposition on the landscape is subject to new designs.

None of this means, though, that religious practice in the region is anything less than what it once might have been. Apart from Tibet, where religious institutions were systematically destroyed by military campaigns and certain practices outlawed among the local populace, the visible changes witnessed at a sacred site tend to be gradual and incremental, occurring alongside the more profane alterations in the landscape, and religious practice is barely affected by them. Urbanization and a spreading megalopolis, for instance, overtake spiritual places in the Kathmandu Valley, threatening to remove them from view, but these sites remain vital for local worship. Pilgrimage destinations in Nepal and India are developed as tourist attractions, so that recreational and spiritual travelers find themselves together at a site with different, not wholly contradictory, purposes. Litter and graffiti may blemish the facades and grounds of temples or monasteries in urban settings, yet do little to deter their spiritual functions. More lamentable, perhaps, are the brazen violations of sacred space that occur when religious artifacts are plundered for commercial sale, or when spiritual monuments are razed to make room for new shopping centers or housing projects, swept away by landscapes, inundated by the rising waters of a hydropower reservoir, or, in the egregious case of Tibet, destroyed as a matter of government policy. This all makes it more difficult for one to see the transcendent power of spiritual places in the landscape. When its visible markers become more obscure, the memory of living in a sacred world loses some tangible evidence and a sense, perhaps, of a geographical immediacy.

Opposite: Temple and basketball court, Shangri La, Tibet (Yunnan, China), 2006.

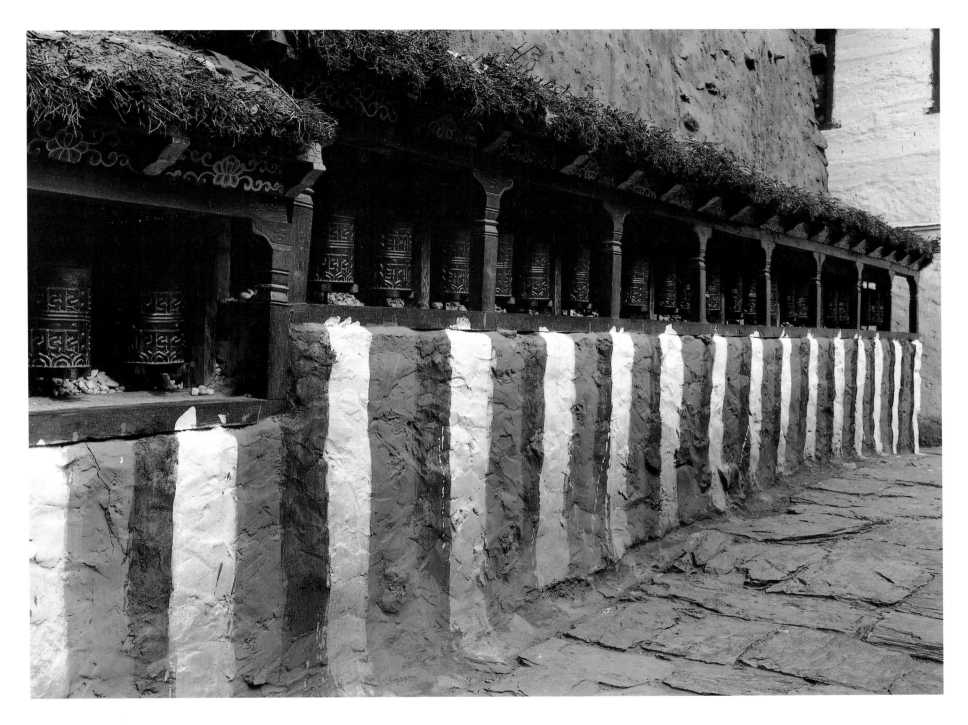

Prayer wheels (spiritual technology), Mustang, Nepal, 2008.

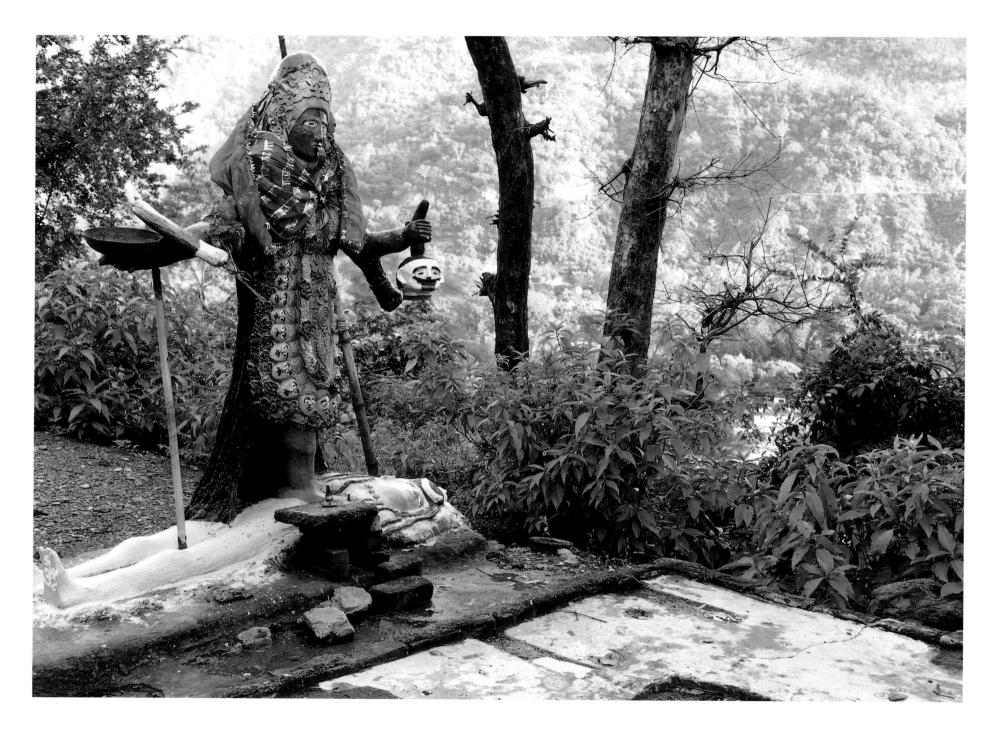

Kali shrine, Rishikesh, India, 2004.

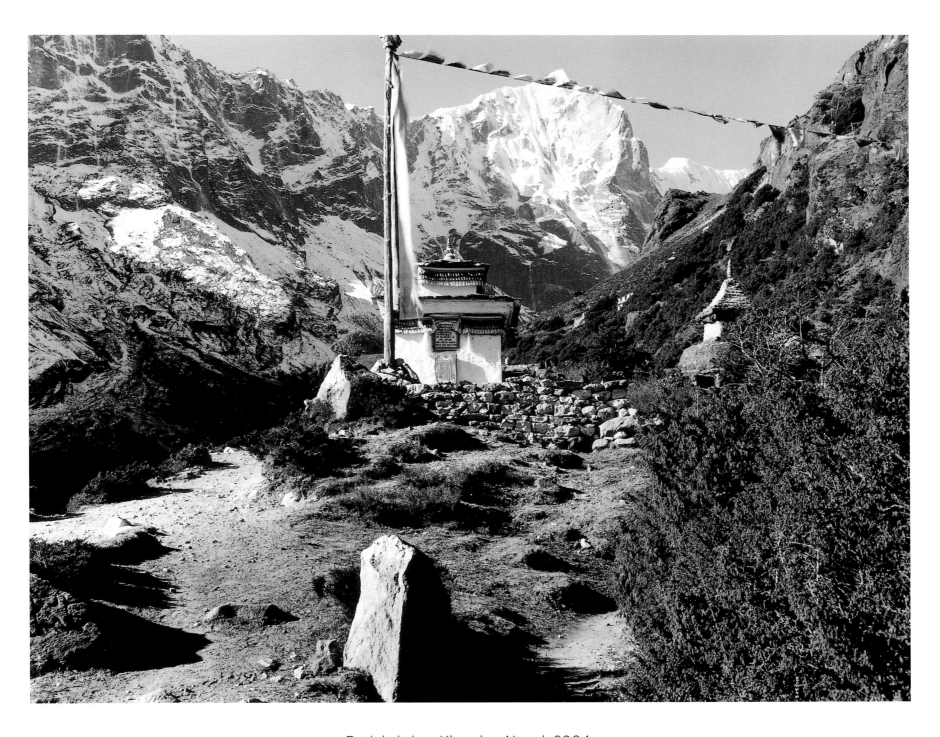

Burial shrine, Khumbu, Nepal, 2004.

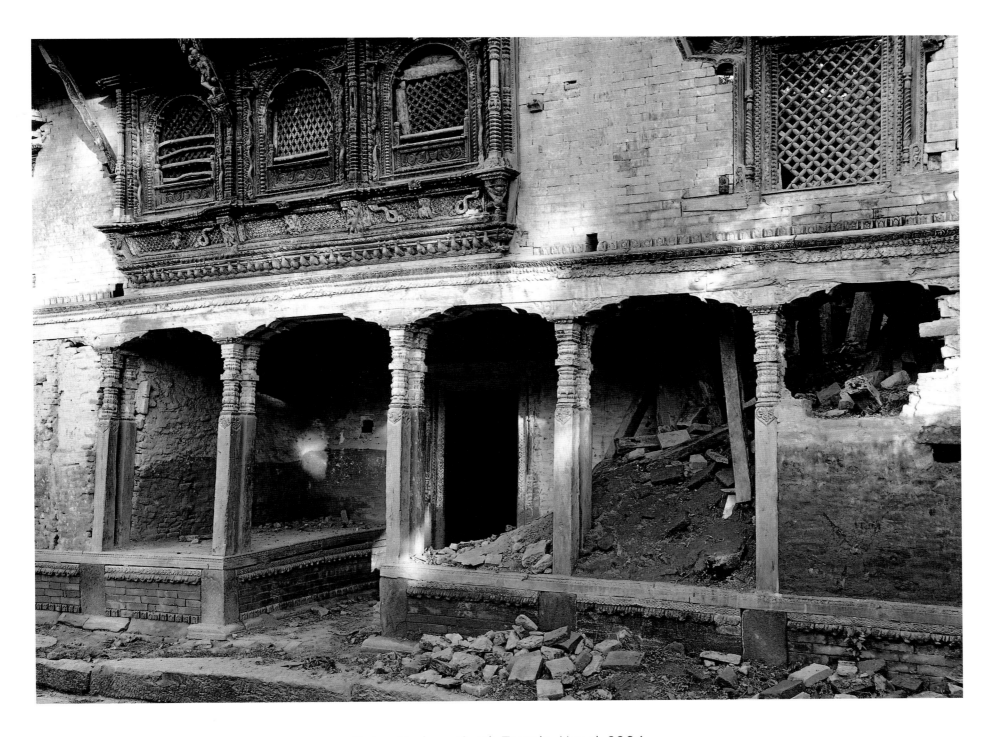

Ruins, Pashupatinath Temple, Nepal, 2004.

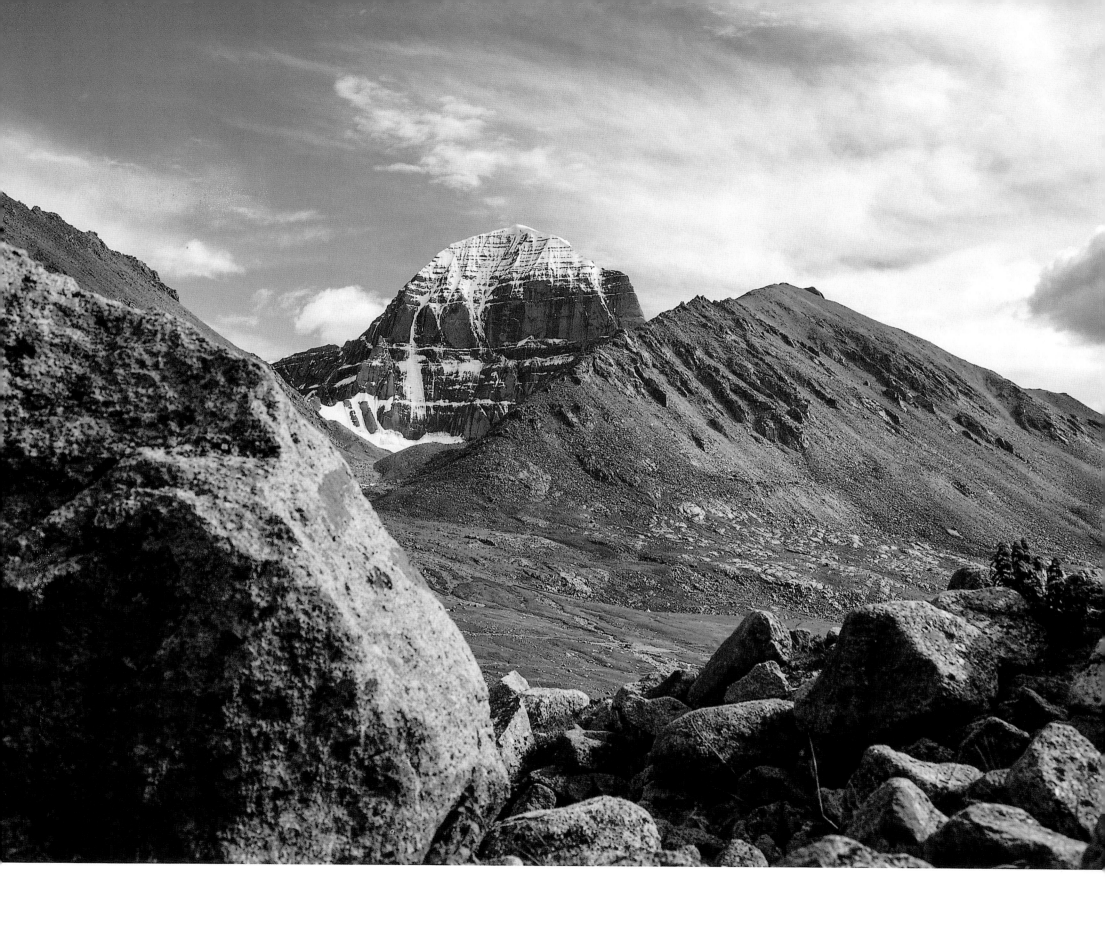

ACKNOWLEDGMENTS

A project such as this one, spanning a decade and much challenging terrain, happens only with a great deal of assistance and support. I'd like to thank the following individuals and institutions for their help during the course of my work on this book.

In Bhutan: Karma Dorji, Chencho Tsering, Dawa Zangpo.

In China/Tibet: Li Bo, Norbu Gesang, Devika Gurung, Dakpa Kelden, Mark Larrimore, Sam Mitchell, Tsering Phuntsok, Lobsang Tenzing, Norbu Tinle, Dorje Tsedan, Lu Yuan.

In India: Anil Aggarwhal, Umesh Akre, Ibrahim Chapri, Praveen Grover, Tsering Gyalpo, Dilli Raj Joshi, Anil Khachi, P. K. Khosla, Harprit Singh, Rana Singh, Dhanu Swadi, Phuntsog Wangtak.

In Nepal: Ganga Das Baba, Anil Chitrakar, Kiran Man Chitrakar and Ganesh Photo Lab (for darkroom facilities in Kathmandu), Sumitra Manandhar Gurung, International Centre for Integrated Mountain Development (ICIMOD), Tom Kelly (for the offer of a tripod in a time of need), Thomas Mathew, Sarita Pariyar, Prakash Pathak, Tshering Sangmo, Bhim Subedi, Karsang Tamang, Deepak Thapa, Tibet Guesthouse, Amrit Tuladhar, Laurie Vasily, Indra Yonzon and Green Hill Ltd. (for logistical support).

In the United States: Eastern Kentucky University (for long-standing institutional support); Ashok Gurung and the India-China Institute at The New School, New York City; Paul Kallmes; Pradyumna P. Karan; Kentucky Arts Council (for the Al Smith Visual Artist Fellowship); Robert Morton; Andrew Quintman, Sara Shneiderman, Mark Turin, and the Himalaya Initiative at Yale University, New Haven, Connecticut; George Strange (for his support on all my various projects, including this one); Éric Valli (for sharing friendship and photographic insights on Red Lick and for writing the book foreword); Steve Wrinn and the University Press of Kentucky staff (for faith in the book); and, as always, Jennifer Zurick.

I wish especially to thank Richard Farkas for his gracious book design, Holly Troyer for drawing the lovely map, and Chris Radcliffe for joining me on a picture pilgrimage to Mt. Kailash.

Opposite: Mt. Kailash, Tibet, 2013.

Metal cylinders on a spindle, stamped with a mantra and filled with ritual items, are turned by Tibetan Buddhists in acts of worship. The prayer devices take various forms: handheld wheels, wheels in a stream turned by flowing water, wind- and sunshine-driven wheels, electric wheels, and nowadays, digital prayer wheels attached to a computer hard drive. Like others, I found it difficult to pass a row of prayer wheels and not give them a reverent spin. It makes no difference if one's mind is distracted or the gesture tentative; the act itself is believed to be meritorious enough when done with an open heart.

96 Kali shrine, Rishikesh, India, 2004. The forests above the holy town of Rishikesh are filled with shrines and meditation caves. I came across an altar dedicated to Kali, who is revered by Hindus as a tantric goddess—mistress of time and change, demoness, and the mythological consort of Shiva. The forest deity is depicted in a necklace of human skulls standing triumphantly atop Shiva's prone body. In tantric practice, Kali signifies both annihilation and redemption, and the altar attracts yogins from throughout India who come to the forest to meditate on her contradictory qualities.

97 Burial shrine, Khumbu, Nepal, 2004. A shrine on a ridge above the Bhote Kosi Valley commemorates a local youth who died fighting in a foreign war. The sacred geography of Tibet and the Himalaya has gone global: the mountaintop shrine was financed by Sherpa taxi drivers living in New York City. Meanwhile, Hindu priests consecrate new Himalayan ashrams for an international clientele; Tibetan clergy jet-set freely among study centers located in Paris,

New York, or London; swamis from India run meditation retreats in the European countryside; and tourists from around the world visit sacred places in the mountains on journeys that may take them to the distant horizons of their geographical imagination.

99 Ruins, Pashupatinath Temple, Nepal, 2004. Straddling the Bagmati River in the Kathmandu Valley is the sixteen-hundred-year-old Pashupatinath Temple, thought to be one of the most sacred places in the world devoted to the Hindu deity Shiva. The temple complex is filled with golden-roofed pagodas, smoking *ghats,* and carved-stone shrines. It is always a busy scene by the river, and I found myself drawn to the forest above the temple, where the old buildings were disappearing amid rotten timbers, vines, and crumbling stone—the architectural saga of an ancient faith slowly dissolving back into the quiet woodlands.

100 Mt. Kailash, Tibet, 2013. The sacred center of the world mandala for Himalayan pilgrims is the 6,714-meter summit of Mt. Kailash—mythological Mt. Meru, the *axis mundi* connecting heaven and Earth. Hindus believe it to be the abode of Shiva. Tibetan Buddhists consider it the topographic manifestation of compassion and goodness. For Bonpos, it is the mystic soul of the universe. A ritual circumambulation of the mountain is thought to wipe out the sins of a lifetime. The sacred mountain straddles the divide between India and China as it towers over the headwaters of several great Asian rivers, including the Indus and Brahmaputra. It is the final place I visited for my Sacred Geography series and the first I photographed with a digital camera, thus rendering its divine image in a pixelated form.

SELECTED BIBLIOGRAPHY

Religion and Landscape in the Himalaya and Tibet

There is an extensive literature on spiritual landscapes in the Himalaya and Tibet that has informed my thoughts about sacred places and the photographs I make of them. Some essential titles are listed below for those wishing to delve deeper into the subject.

Baker, Ian. *The Heart of the World: A Journey to the Last Secret Place.* New York: Penguin, 2004.

Bernbaum, Edwin. *The Way to Shambala: A Search for the Mythical Kingdom beyond the Himalayas.* Boston: Shambala, 2001.

Bhardwaj, Surinder. *Hindu Places of Pilgrimage in India: A Study in Cultural Geography.* New Delhi: Munshiram Manoharlal, 2003.

Bishop, Peter. *The Myth of Shangri La: Tibet, Travel Writing, and the Western Creation of Sacred Landscape.* Berkeley: University of California Press, 1989.

Doctor, Andreas. *Tibetan Treasure Literature.* Ithaca, NY: Snow Lion, 2005.

Dowman, Keith. *The Sacred Life of Tibet.* London: Thorsons, 1998.

Eck, Diana. *India: A Sacred Geography.* New York: Three Rivers, 2013.

Feldhouse, Anne. *Connected Places: Region, Pilgrimage, and Geographical Imagination in India.* New York: Palgrave Macmillan, 2003.

Goldstein, Melvin, and Matthew Kapstein, eds. *Buddhism in Contemporary Tibet: Religious Revival and Cultural Identity.* Berkeley: University of California Press, 1998.

Halkias, Georgios. *Luminous Bliss: A Religious History of Pure Land Literature in Tibet.* Honolulu: University of Hawaii Press, 2012.

Huber, Toni, ed. *Sacred Spaces and Powerful Places in Tibetan Culture.* Dharamsala: Library of Tibetan Works and Archives, 1999.

Lopez, Donald. *Prisoners of Shangri La: Tibetan Buddhism and the West.* Chicago: University of Chicago Press, 1999.

Ortner, Sherry. *High Religion: A Cultural and Political History of Sherpa Buddhism.* Princeton, NJ: Princeton University Press, 1989.

Ramble, Charles. *The Navel and the Demoness: Tibetan Buddhism and Civil Religion in Highland Nepal.* New York: Oxford University Press, 2007.

Sax, William. *Mountain Goddess: Gender and Politics in a Himalayan Pilgrimage.* New York: Oxford University Press, 1991.

Shahi, Surendra, Christian Ratsch, and Claudia Muller-Ebeling. *Shamanism and Tantra in the Himalayas.* Rochester, NY: Inner Traditions, 2002.

Singh, Rana. *Sacred Geography of Goddesses in India.* Newcastle upon Tyne: Cambridge Scholars, 2010.

———, ed. *The Spirit and Power of Place.* Varanasi: Banaras Hindu University, 1994.

Slusser, Mary. *Nepal Mandala: A Cultural Study of the Kathmandu Valley.* Princeton, NJ: Princeton University Press, 1982.

Snellgrove, David. *Buddhist Himalaya: Travels and Studies in Quest of the Origins and Nature of Tibetan Religion.* Bangkok: Orchid Books, 2012.

Thubron, Colin. *To a Mountain in Tibet.* New York: HarperCollins, 2011.

Thurman, Robert, and Tad Wise. *Circling the Sacred Mountain: A Spiritual Adventure through the Himalayas.* New York: Bantam, 2000.

Landscape and Place

Geographers and landscape scholars have helped shape the way I see and photograph the world. A few seminal titles are listed here.

Casey, Edward. *Representing Place: Landscape Paintings and Maps.* Minneapolis: University of Minnesota Press, 2002.

Conzen, Michael. *The Making of the American Landscape.* New York: Routledge, 1994.

Cosgrove, Denis, and Stephen Daniels. *The Iconography of Landscape.* Cambridge: Cambridge University Press, 1987.

Duncan, James, and David Ley. *Place/Culture/Representation.* New York: Routledge, 1993.

Entrekin, J. Nicholas. *The Betweenness of Place: Towards a Geography of Modernity.* Baltimore: Johns Hopkins University Press, 1991.

Gregory, Derek. *Geographical Imaginations.* New York: Wiley-Blackwell, 1994.

Groth, Paul, and Todd Bressi. *Understanding Ordinary Landscapes.* New Haven, CT: Yale University Press, 1997.

Jackson, John Brinckerhoff. *A Sense of Place, a Sense of Time.* New Haven, CT: Yale University Press, 1994.

Jackson, Peter. *Maps of Meaning.* London: Unwin Hyman, 1989.

Lowenthal, David. *The Past Is Foreign Country.* Cambridge: Cambridge University Press, 1999.

Malpas, Jeff. *The Place of Landscape.* Boston: MIT Press, 2011.

Massey, Diane. *Space, Place, and Gender.* Cambridge: Polity, 1994.

Relph, Edward. *Place and Placeness.* London: Pion, 1976.

Tuan, Yi Fu. *Humanist Geography: An Individual's Search for Meaning.* Staunton, VA: George F. Thompson, 2012.

———. *Topophilia: A Study of Environmental Perception, Attitudes, and Values.* New York: Columbia University Press, 1990.

Tuan, Yi Fu, and Martha Strawn. *Religion: From Place to Placelessness.* Chicago: Center for American Places, 2010.

Wallach, Bret. *Understanding the Cultural Landscape.* New York: Guilford, 2005.